Collins THE DUFFER'S GUIDE TO
PAINTING WATERCOLOUR
LANDSCAPES

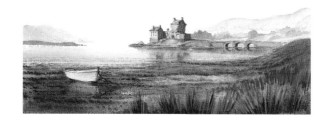

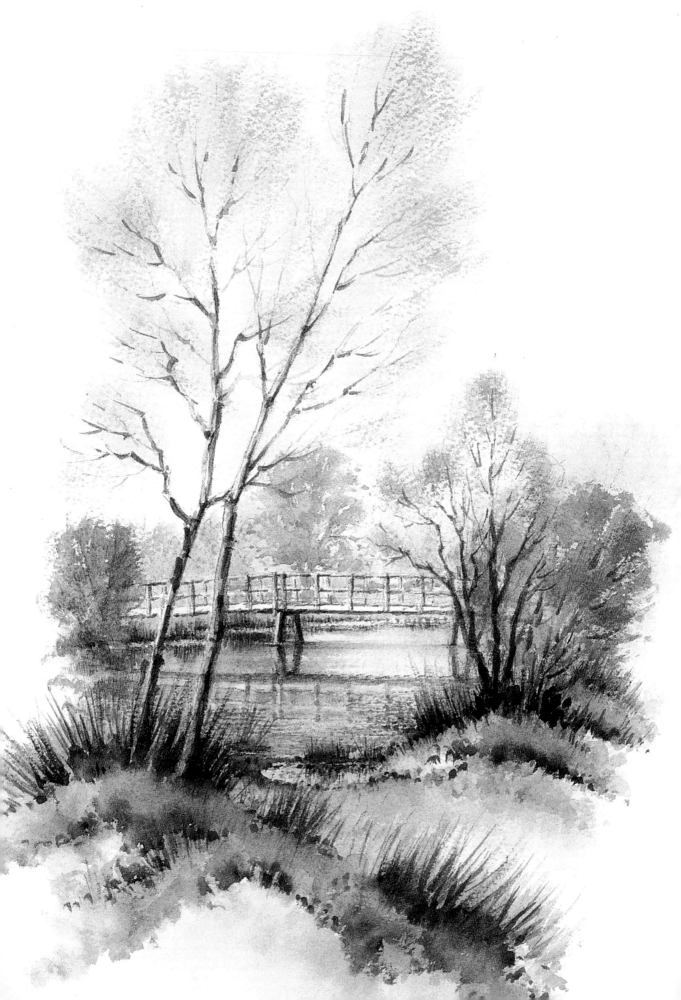

THE DUFFER'S GUIDE TO
PAINTING WATERCOLOUR LANDSCAPES

BASIC SKILLS AND SIMPLE TECHNIQUES

DON HARRISON

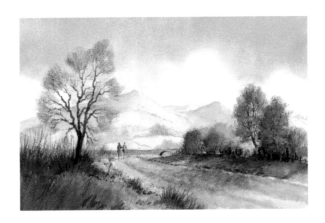

First published in 2000 by
HarperCollins*Publishers*
77-85 Fulham Palace Road
Hammersmith, London W6 8JB

The HarperCollins website address is:
www.**fire**and**water**.com

Collins is a registered trademark of HarperCollins Publishers Limited.

01 03 05 04 02
4 6 8 7 5

A catalogue record for this book is available from the British Library

Editor: Geraldine Christy
Designer: Colin Brown
Photographer: Nigel Cheffers-Heard

A companion video, entitled *The Complete Duffer's Guide to Painting Watercolour Landscapes*, is available from Artyfacts, P. O. Box 2182, Poole, Dorset BH16 6YU

ISBN 0 00 413399 4

Colour reproduction by Colourscan, Singapore
Printed and bound by Rotolito Lombarda, Italy

Page 1: E I L E A N D O N A N 35 x 53 cm (14 x 21 in)
Page 2: L A K E A T M O O R S V A L L E Y 56 x 37 cm (22 x 14½ in)
Page 4: V I E W F R O M S H I N A F O O T 33 x 51 cm (13 x 20 in)
Page 5: M U D E F O R D 37 x 56 cm (14½ x 22 in)

Contents

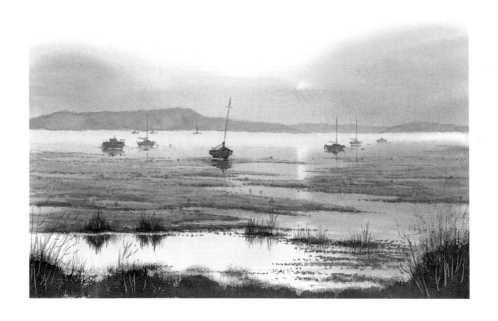

Introduction

Even in this day and age we can still be overwhelmed at the sight of a stunning view. Indeed you may often hear people say, 'Just look at that. If only I could paint it.' So why on earth do they not do so? Many people say they have no talent for painting or they cannot draw, or the scene is too difficult, or they will take up painting when they retire. Sadly, they are missing out on one of life's great pleasures. Even worse, a large proportion of the people who already try to paint often struggle through poor technique and lack of good advice. Some regard themselves as complete duffers and wonder if they will ever improve. This book is intended to change all that and to show just how easy it is to paint effective and realistic landscapes in watercolour.

Here is a basic, but comprehensive, painting course arranged and written in a straightforward, no-nonsense way that is easy to understand. If you have always longed to paint but do not know where to start, here are the answers. The book introduces the materials and equipment you will need and provides a guide to basic colour theory, with advice on laying out your palette and mixing your colours. Techniques are clearly explained, followed by simple exercises to help you put them into practice. Finally, each chapter culminates in a full step-by-step demonstration of a painting.

▼ *MORNING SNOW*
38 x 56 cm (15 x 22 in)
The heavy overcast sky provides just the right backdrop to the distant snow-covered fields and is painted using the same cold blues and violets that are used for the snow-bound lane and fields. These wintry colours contrast well with the rich, warm browns in the hedges and trees.

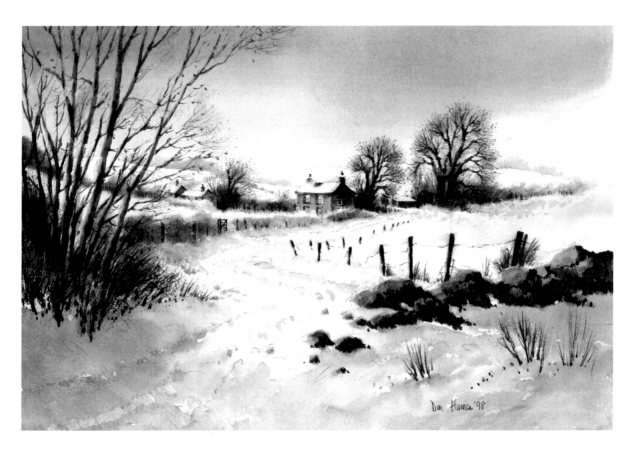

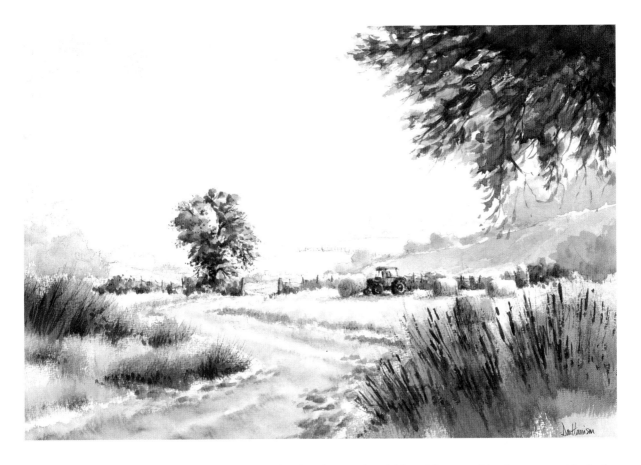

▲ *H A R V E S T T I M E*
37 x 56 cm (14½ x 22 in)
The light fluffy clouds in a blue sky suggest a warm summer's day and the bright, warm yellows and greens, framed by the dark overhanging foliage, emphasize this feeling. The tractor provides a touch of action and a useful focal point in the painting.

After reading this book you should be able to tackle almost any kind of scene with confidence. But if some of your early efforts are unsuccessful do not worry – remember that you are only spoiling a piece of paper. Even your reject pictures should teach you something useful for future paintings as long as you understand where you went wrong.

When you first start painting the temptation is to reproduce exactly what you see, but the camera can do this much better than you or I. So once you have chosen a subject, try to simplify it and produce a reasonable impression of it without including every detail. When your painting does come out right you will realize what you have been missing all these years.

Your days as a 'duffer' are numbered!

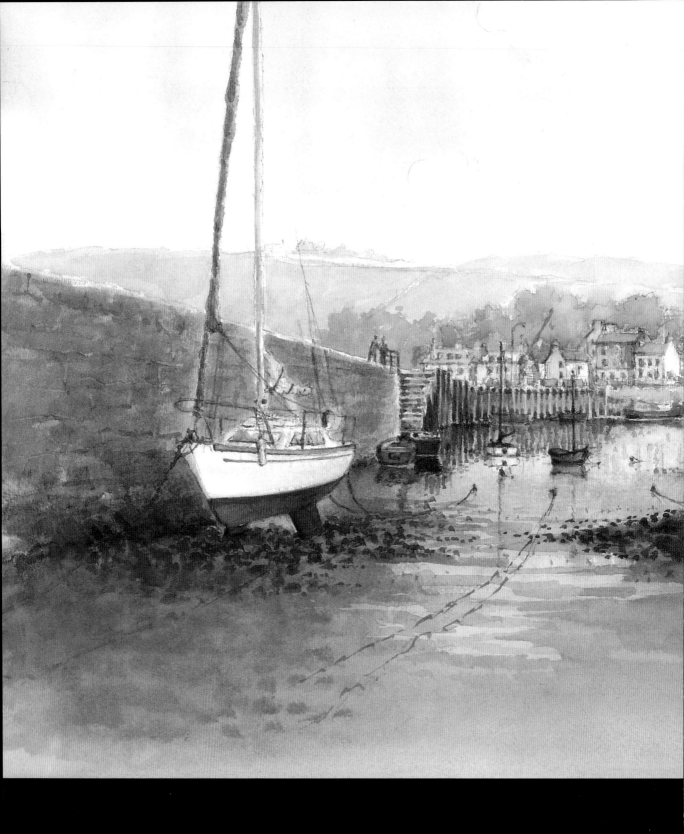

MATERIALS AND

◀ *STONEHAVEN HARBOUR*
38 x 56 cm (15 x 22 in)
*This busy harbour was packed with boats, so
I simplified the scene, including just enough
detail to make it interesting. You can make full
use of your range of brushes when painting a
complex scene like this.*

Like most hobbies, painting requires an initial outlay in materials and equipment. It is all too easy to be misled into making a poor choice and many beginners buy huge amounts of materials and equipment when only a few basic items are really needed to get started. In the long run, it pays to use really good-quality materials and ensure that you have the right tools for the job. Then all you need is to learn how to use them to the best advantage – I hope this book will take care of that.

As far as paints are concerned, you will probably read a lot of conflicting advice about how many colours you should have. Most professional artists have their own particular favourites, but make your selection based on common sense and your own preferences. Paper is very much a personal choice and it is worth experimenting to find the surface that suits you best.

EQUIPMENT

▶ *I recommend using artists' tube colours. My preferred starter selection would be Cadmium Red, Alizarin Crimson, Cadmium Yellow, Lemon Yellow, Cobalt Blue, French Ultramarine, Raw Sienna, Burnt Sienna and Burnt Umber.*

Paints

Paints are normally sold in tubes or as flat pans. I suggest you avoid pans because it is more difficult to load the brush properly, especially when the pan is hard. Even when pans are soft and moist they still do not offer the flexibility of tubes, which allow you to squeeze out the amount of paint you want when you need it. Most people start off with the old paintbox they used at school with horrid little hard pans of paint and dreadful cheap brushes. If you try using a large brush to pull out a single colour from these pans it is difficult to avoid picking up the colours on either side. There is very little space to mix colours, so the chances are that you will put lots of water into one of the wells and finish up mixing watery colours. Do yourself a favour and throw your old paintbox away.

If you can, buy the best artists' colours you can afford. They are a pleasure to paint with and give you stronger, more vital colours that will impart more zing to your paintings. Students' quality may be less expensive, but the colours are often insipid and the pigments lack strength, so you may use more paint in the long run.

Palette

My preferred option is a circular plastic palette, offering ample space for mixing and room to fit the colours round the edge. If you arrange them in a set position, it is a simple matter to locate the colours easily without having to think where they are each time. You can use alternatives to this type of palette – for example, an enamel plate or a plastic butcher's tray. But the important point is to have a large mixing area.

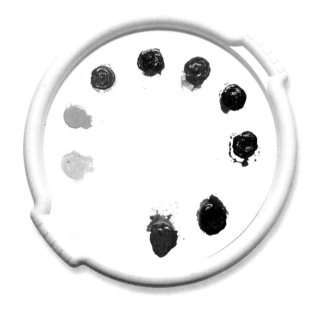

▶ *Place generous amounts of your colours evenly spaced around the edge of the palette, leaving a large mixing area in the centre.*

Brushes

Duffers often seem to be over-equipped in this area as they are easily swayed by marketing claims of special properties for gimmicky brushes. Experience will prove that you only need a few brushes if you learn how to use them properly. My own collection includes the following brushes.

Hake – 50 mm (2 in). Buy a stitched variety with plenty of body. Good-quality hake brushes do not splay out because the goat hairs bend inwards at the ends, making it easy to form a 'chisel' edge. Avoid hakes with metal ferrules – these are more suited to stippling or cleaning your water buckets.

Flat brushes – 25 mm (1 in). Use a smaller one if you find this size hard to handle. A synthetic brush is quite acceptable, but check before you buy that the bristles will form a neat chisel edge without separating when damp.

Medium round brushes. A size 5 or 6 and an 8 are useful for finer work. It pays to buy quality here – Kolinsky sable by choice, as these hold their shape and form a good point for finer work. They should be 'springy' when dry.

Large round sable. A size 14 is ideal for large washes. Mine has a blunt end because I do not use this for delicate shapes, so it is unnecessary to have one with a point.

Long-haired size 1 rigger. This is perfect for fine detail and is more controllable than a small round brush for fine work.

Filbert hog brush. Usually associated with oil painting, a bristle brush is ideal for lifting out colour or using with dry paint for foliage or hedgerows.

Goat-hair mop or Squirrel brush (optional). Useful for sky washes and clouds.

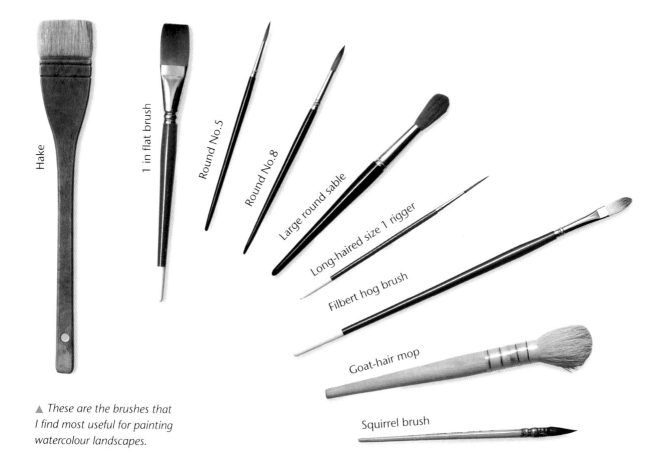

Hake

1 in flat brush

Round No.5

Round No.8

Large round sable

Long-haired size 1 rigger

Filbert hog brush

Goat-hair mop

Squirrel brush

▲ *These are the brushes that I find most useful for painting watercolour landscapes.*

Watercolour paper

Beginners often start with pads or blocks. However, pads are only suitable for sketching as the loose flapping edges make it impossible to keep the paper flat – clipping the sheets together at the corners can help. Most pads and blocks consist of sheets of thin paper, with the result that when you damp the top sheet you also damp the one below. Then they both tend to cockle and it is hard to control the moisture and the paint.

Unless it is stretched, thin paper cockles when water is applied liberally. Instead, use single sheets of good quality 100 per cent rag paper – 400 gsm (200 lb) or thicker. Try out different makes to find the best surface for you. Choose paper with a slightly rough surface, either Not (Cold Pressed) or Rough. Avoid Hot Pressed, which is too smooth. Heavy paper is expensive, but at least you can use both sides. Keep odd pieces of the same paper you use for painting for testing paint consistency and mixtures and for wiping surplus paint or water from your brush.

Other useful items

As well as paper, paints and brushes there are several other items that you will need in the course of painting.

Pencils

Hard, thin-leaded pencils tempt you to draw rigid straight lines and work in a fussy, detailed way. Soft-leaded pencils, ranging from 2B to 7B, will encourage the use of ragged strokes and a looser approach to your work. Avoid holding the pencil like a writing pen, with a rigid forefinger. Hold it higher up and use flowing

▶ *A painting box incorporates a lift-up easel. It can also be used to store your painting equipment.*

strokes. Instead of straight lines, move the pencil point up and down a little as you move it to create a jagged line. Leave a few gaps in the line here and there – the viewer will fill them in visually. Think like an artist, not an engraver.

Erasers

Use erasers sparingly to avoid damaging the paper surface – a soft putty eraser is best. Leave the rough pencil outlines on the paper when you are painting, unless they are very heavy.

Sketch pads

Carry a sketch pad around to make quick drawings of any interesting subjects you come across. For colour reference sketches use watercolour pads or small loose sheets. Cartridge paper is fine for sketching, but useless for painting on as it has a poor surface.

Easels

A metal easel is light in weight but stable enough for working on location. I work with the board fairly upright, which discourages the use of excess water. You should be able to tilt the board to a horizontal position when required to control the movement of wet paint. Painting boxes also provide a useful easel. A low-cost alternative is to use wooden blocks to slope the backing board.

Backing board and clips

It is essential to keep the paper flat while working, so attach it to a backing board cut slightly larger than your selected paper size. Thin plywood or blockboard is ideal. Use spring clips to retain the paper at each corner. This method also allows you to pull the paper flat if it bulges a little after damping. Do not stick masking tape all round the edge of the paper or it will ridge up like a corrugated roof when water is liberally applied to the surface.

Water pots

Always use two plastic water pots or jars – one for rinsing your brush and one for clean water for mixing – or you will never paint fresh-looking paintings. Make sure the top opening is large enough to take your largest brush. Position the pots below the level of your painting to avoid splashing your work.

▲ Don Harrison in his studio. He uses both a lightweight metal easel and a painting box, which allows him to be flexible in his working approach.

Kitchen roll

Use absorbent kitchen roll rather than tissue, which can leave a fluffy residue on your paper.

Palette knife

Widely used by oil painters, a palette knife is an excellent tool for lifting out paint to suggest light stems or trunks of trees. It can also be used flat to the paper for moving paint around to create a textured effects on rocks.

Masking fluid

Masking fluid, or Frisket, is useful for masking off small white areas. Apply it with a damp or soapy brush to make the bristles easier to clean. Only remove the masking when the paper is fully dry.

US

Used in the right way, colours can create visual excitement or a mood of peaceful tranquillity. They can be garish and strident or restful and harmonious, bold and powerful or incredibly subtle. Colours can make or mar a painting, so they are a crucial part of picture making. But for the new painter, choosing the right colours and understanding how to mix them can be a minefield.

The plethora of books, videos and magazine articles simply adds to the confusion, offering an overwhelming amount of conflicting advice. Some suggest a limited palette, while others promote the use of many hues.

Most people require a simple-to-understand, easy-to-remember system for selecting, mixing and adjusting colours. This chapter provides a logical explanation for choosing particular colours, with some simple mixing techniques to help you arrive at the hue you want quickly and easily.

NG COLOUR

Primary colours

As children, we are taught about colour in simple terms. We are shown how the colours of the rainbow can be formed into a circle to make a colour wheel and told how the primary colours red, yellow and blue cannot be mixed from any other colours. For artists, this basic thoeretical knowledge can help the colour mixing process. Use the order of the colours in the colour wheel as a handy guide for arranging the paints on your palette.

▲ *Primary colours – reds, yellows and blues – are so called because they cannot be mixed from other colours. They form the basis for all colour mixing.*

Complementary colours

Most of us know what happens when different primary colours are mixed together – red and yellow make orange, blue and yellow give green and red and blue produce violet. By adding the second primary in each case, a secondary colour mix is produced. Logically, if these secondary colours can be mixed from the primaries, there is no need to buy them for your palette.

Each secondary colour, having been mixed from two of the primary colours, is usually referred to as the complementary colour of the other primary. Thus the complementary colour of red is green (a mixture of the other two primaries), the complementary colour of yellow is violet and the complementary colour of blue is orange. So what, I hear you ask? The useful point to remember is that placing complementary colours next to each other makes each of them stand out vividly. On the other hand, mixing all three primary colours together in roughly equal amounts results in dark grey or muddy colours and should be avoided.

Even when you know how to mix these combinations of primary colours, you may still find it difficult to make a particular hue. You would be right in thinking that a few more colours might be useful. But what colours should you choose and in any case why select particular primaries instead of alternative reds, blues or yellows, and what difference will choosing different ones make? Read on!

▼ *The standard colour wheel, showing six colours. These are the three primaries – red, yellow and blue – and the three secondary mixes – orange, green and violet.*

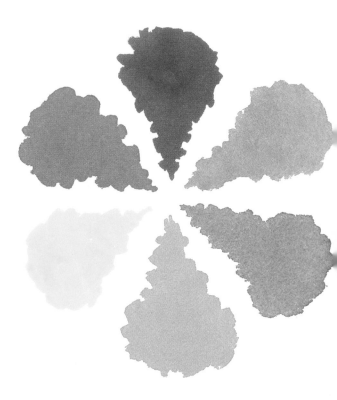

Warm and cool colours

When we look at colours they have an obvious warm or cool appearance. In fact, we tend to think of violet/blue/green colours as cool and red/orange/yellow colours as warm. This warm or cool look can be used to create a mood or seasonal influence.

If your selected colours include a cool and a warm version of each primary this gives you the flexibility to mix almost any colour you wish. Manufacturers have different names for similar colours, so choose them visually. For example, Lemon Yellow and Aureolin have the greenish yellow appearance of real lemons whereas Cadmium Yellow Deep and Gamboge will both lean towards orange and look like strong custard. Do not buy ready-mixed greens, oranges or violets – these can be mixed from the primaries.

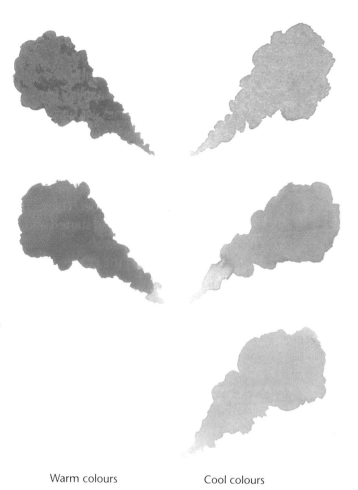

Warm colours Cool colours

▼ *THE VALLEY*
34 x 57 cm (13½ x 22½ in)
The warm colours of the foreground grasses and mountains on the right are in stark contrast to the cool blue/green slopes of the other mountains in shadow. Using a juxtaposition of warm and cool colours is an effective way of giving the impression of depth.

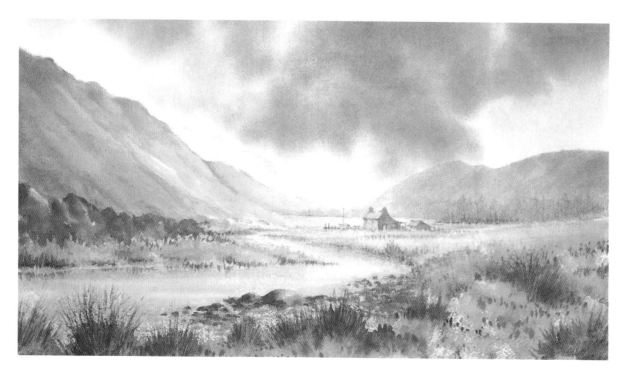

Mixing vibrant colours

There are many instances where you need pure, vivid colours and to do this we use adjacent primaries. When you mix two primaries together that are nearest to each other on the colour wheel, the result is a very intense secondary colour. Alizarin Crimson is more blue in appearance than Cadmium Red and has a leaning towards violet. French Ultramarine also leans towards violet, unlike the cooler blues, so with this affinity they make a clean-looking violet colour when mixed together.

Lemon Yellow, which is cool and greenish looking, when mixed with Cobalt Blue, produces a clear fresh green, ideal for spring foliage. Coeruleum, a very cool greenish blue, would work even better, but as this is a very powerful staining colour that is hard to lift out it is best avoided by beginners. Cadmium Red, with a leaning towards orange, mixed with the warmer of the yellows, Cadmium Yellow, produces a rich and vibrant orange. The positioning of the pairs of warm and cool primaries on the palette makes selection of these vibrant mixes simple.

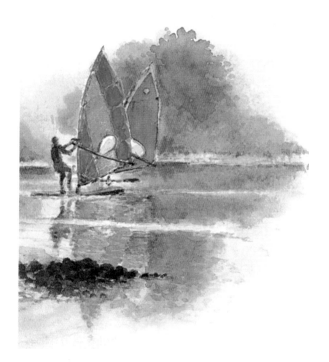

▲ *BOARD SAILING*
15 x 13 cm (6 x 5 in)
Using pairs of adjacent primaries mixed together results in the essential vivid *colours needed to portray the sails. The strong green colours of the background trees make the sails stand out even more.*

Avoiding muddy colours

If you add three primaries together in roughly equal quantities the result is grey or 'mud' and this can happen very easily without you being aware of it.

For example, you may have mixed yellow and red and finished using the orange that resulted. If some of the remnants of this are inadvertently left on the palette (or you have not cleaned your brush properly) you will find when you mix the red with blue to make a pleasant violet, for instance, that the result is often very drab. The reason is that some of the previous mixture blends with the new mixture. As the orange residue contains yellow, when added to your two new colours, red and blue, the result is a blend of all three primaries again. So, to avoid this, clean the mixing area often or keep different colour mixes on separate sides of the palette and clean your brushes properly in between mixes.

▼ *Mixing adjacent primaries produces the most vibrant secondary colours.*

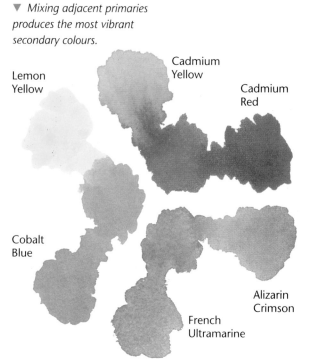

Lemon Yellow

Cadmium Yellow

Cadmium Red

Cobalt Blue

Alizarin Crimson

French Ultramarine

Neutralizing colours

Just as vibrant hues can be mixed from two adjacent primaries, so a neutral hue can be produced from mixing two primary colours that are not adjacent on the colour wheel. In fact, the further apart they are, the more neutral or dull they become because the colours 'lean' in the wrong direction.

Mixing just two primaries together is slightly limiting and may not produce the subtle hue you need, so what about mixing three together to produce neutral tints? This seems to contradict the advice I have just given you: it is true that mixing equal amounts of the three primary colours produces a very dull grey or muddy mixture. The important point is to add just a tiny amount of the third primary to produce a neutral hue. To tone down a single primary, just add tiny amounts of the other two primaries.

The beauty of arranging your colours on a round palette to match the colour wheel is that complementary colours, whether mixtures or individual colours, are always roughly opposite each other, so you know where they are without having to think about it.

Mixing a specific neutral colour

Once you start painting you will need to be able to mix specific colours. For example, you may want a fairly dull orange colour to paint a rusty metal gate. The first step is to decide which two primaries will produce the nearest basic colour – in this case, yellow and red. Next, is a warm or cool colour required? Assuming the answer is warm, the best choice would be Cadmium Yellow and Cadmium Red. Mixing in a tiny amount of a complementary colour – say, French Ultramarine – should dull the colour down. Experience will show you the amounts of each colour to use. Sometimes, a mixture of warm and cool primaries may fit the bill better.

Whenever you adjust a colour mix, pull a little of the main mixture of colour to one side and use a small quantity to try out the new blend.

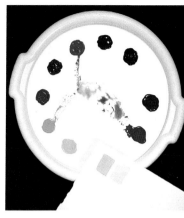

▶ *A blue primary is tested on a piece of scrap paper. Then a small amount of each of the other two primaries – red and yellow – is mixed into the edge of the blue paint to make a more subdued blue. Compare the result with the starting colour.*

▶ *The bright yellow primary has a small amount of red and blue added to tone it down. Check the results again. Adding more or less of the red and blue influences the tone of the final colour. Remember to adjust the colour mix in small increments – it does not pay to be heavy handed.*

▶ *To tone down a red primary a little green is added – in other words, some of its complementary colour (blue plus yellow).*

▶ *Adding the complementary colour is not the only way to diminish a colour's intensity. This time, to tone down a red primary a touch of another darker colour close to it on the colour wheel, Burnt Sienna, has been blended in. The result is a dulled brownish red that is less grey than if the complementary colour was used.*

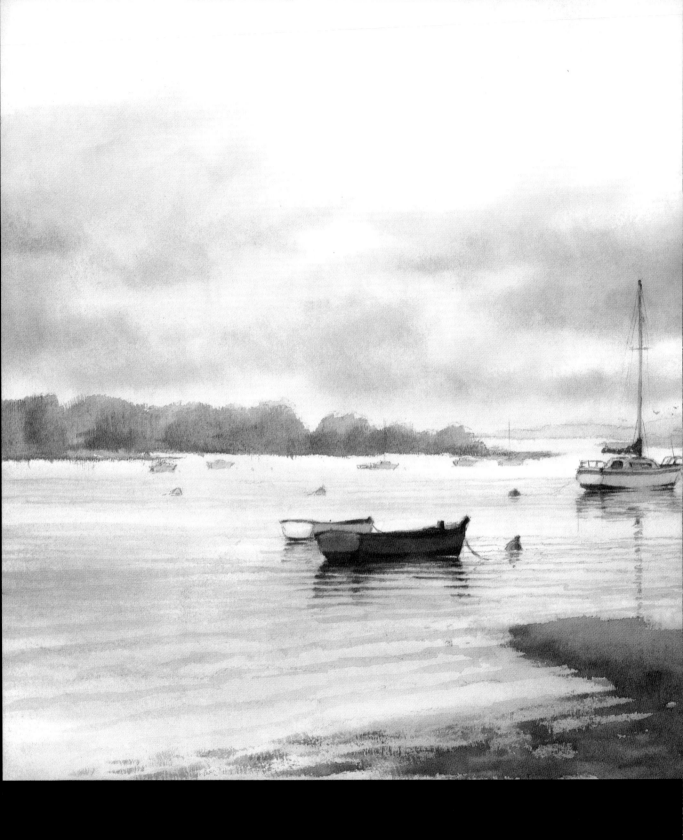

FIRST STEPS IN WA

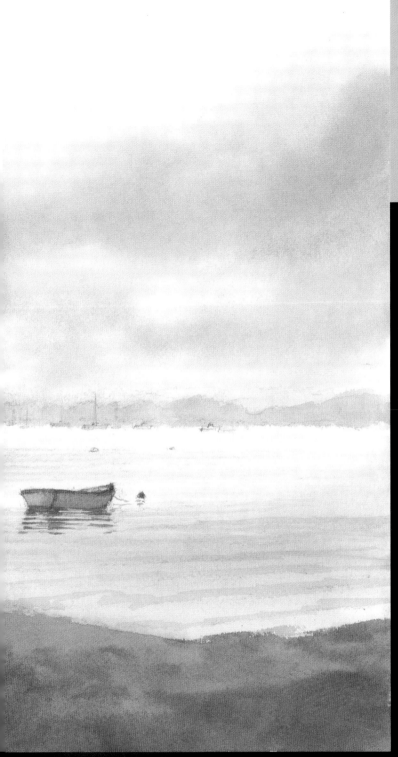

Many new painters start by attempting complete paintings without any background knowledge at all and when these end in disaster they give up, thinking that painting is too difficult. It is rather like attempting to construct a self-assembly item without reading the instructions. Many quite experienced painters struggle for years without understanding where they are going wrong and never achieve their true potential.

Three key aspects of painting in watercolour should be absolutely clear in your mind before you even start – how to paint wet-on-dry, how to paint wet-in-wet and how to use tonal contrast to create the illusion of depth. Why not take the time to become really familiar with these basic principles to help you to understand more clearly how watercolour works? Then you will be ready to tackle your hobby with more confidence

TERCOLOUR

Painting wet-on-dry

When you first start painting you will, no doubt, tentatively dab a dripping wet brush into the paint and deposit a large pool of this onto the paper. It is far better to damp the brush, then remove surplus water on the side of the water pot first of all, before loading the brush with a generous quantity of paint and stroking it across the paper surface with a bold movement.

The process of applying wet paint to the dry surface of the paper is, not surprisingly, called wet-on-dry and this technique is used when you wish to produce a crisp edge to the painted area. Painting wet-on-dry and leaving a narrow gap between one painted area and another also allows you to paint continuously without waiting for each area to dry, which speeds up the painting process considerably.

▼ *Leaving small gaps between colours avoids the risk of bleeding, allowing you to paint more rapidly.*

▲ *The outer edges of each painted area do not need to be precise* (left). *As long as shapes are recognizable, rough edges can look looser and more artistic* (right). *Paint outer edges first, then fill the rest.*

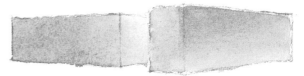

▲ *The same strength of paint need not be used to cover the whole of a particular area. By adding clean water you can achieve graduation in colour for added emphasis and interest. Leaving tiny random unpainted pieces can add sparkle to the effect.*

▲ *Allowing two areas to touch makes paint 'bleed' from one to the other, which can often create additional interest, especially when they are painted in different colours.*

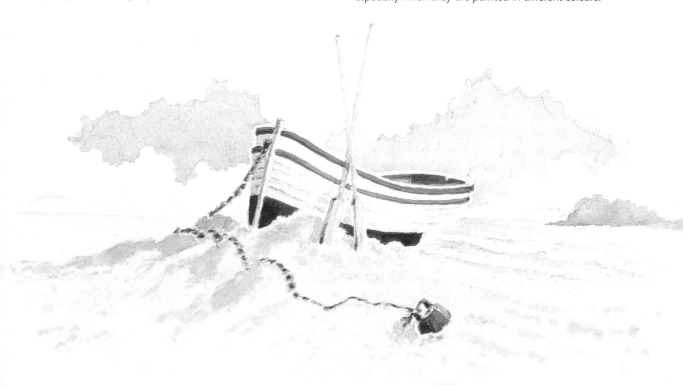

Overpainting wet-on-dry

When each area of paint is dry you can, if you wish, paint another layer on top of it to make a darker colour or stronger tone. Painting a different colour on a dried area is also useful for suggesting the shape or texture of an object or emphasizing the contours of the land.

If you are trying to overpaint the complete underlying shape this needs to be done with care because it is almost impossible to match the outer edges without leaving unwanted double lines of colour. As the paint dries on the paper it becomes lighter, so remember to mix it a little bit darker than you need. Always test the colour first on a spare piece of watercolour paper.

▲ *The texture and shading on the wooden stile has been brought out by overpainting where required.*

▼ *To suggest the misty lower slopes, damp the paper below and work the moisture up into the paint.*

There are occasions when you need to paint a crisp-edged shape wet-on-dry and then create a soft edge to one side – for example, to show mist gathering at the base of a mountain. In this instance you require a crisp shape at the mountain top and a soft edge at the bottom. To achieve this, brush some clean water onto the dry paper below the mountain, leaving a small gap, then work this up into the damp edge of the painted area above. The wet paint will then blend softly into the newly damped area. Avoid brushing clean water straight into the edge of the wet paint without leaving a gap because the water will merge too quickly and you may get a nasty stain.

WET-ON-DRY SUMMARY

FACT If you apply wet paint on dry paper you create crisp edges.

FACT Overpainting a second layer wet-on-dry makes a darker colour or stronger tone.

FACT Overpainting a different colour wet-on-dry helps indicate shape, form and texture. If you overpaint a dry area it is difficult to match the edges without leaving a double line.

FACT Watercolour dries lighter than it appears when wet.

Painting wet-in-wet

One of the most exhilarating ways of applying paint to the paper is to damp the paper surface first with clean water and paint onto it. This is called painting wet-in-wet and the damp surface results in the painted area having a soft blended edge. A strong paint mixture can be used because the moisture in the paper diffuses the paint, making it lighter in tone. Too watery a mix can result in unsightly stains and loss of control.

To determine how strong a paint mixture needs to be in relation to the dampness of the paper, try mixing a small quantity of fairly watery paint and also a stronger, drier mix. Then apply each in turn at intervals, using a piece of the watercolour paper you usually work on so that you can compare them. Damp the surface of the paper thoroughly with clean water and allow it to soak in for a couple of minutes. Do not apply paint to the dampened surface immediately as it will be much too wet. At set intervals – say, every 60 seconds – apply a small brush stroke of first the watery mixture and then the stronger mixture onto the dampened surface side by side and watch the results closely.

While the paper is very damp you will find that both mixtures are uncontrollable. As the paper starts to dry, however, the stronger mixture behaves better, gently blending into the damp surface without spreading too much, while the watery mixture remains difficult to control. If you wait too long, the paper dries too much and the brush strokes leave hard edges.

▼ *Here you can see the different effects achieved according to the strength of the paint and the dampness of the paper. The paint was first applied after 2 minutes (A) and then at intervals of 60 seconds (B–F).*

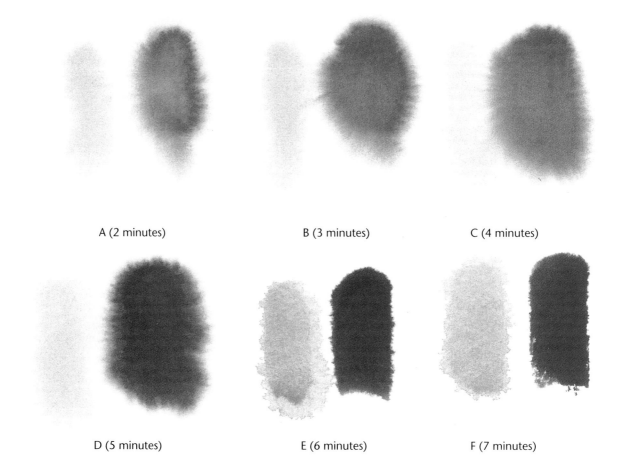

A (2 minutes) B (3 minutes) C (4 minutes)

D (5 minutes) E (6 minutes) F (7 minutes)

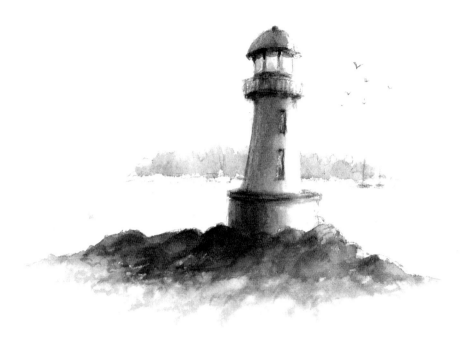

◀ *On the trees, rocks and lighthouse, additional colours were applied while the first layer was still slightly damp. This helped to emphasize the shapes.*

▶ *S U N R I S E*
38 x 28 cm (15 x 11 in)
Painting this simple scene wet-in-wet captures the feeling of serenity and calm water. The soft edges give the impression of a misty morning sun over the lake. Only after these early washes had dried completely were the headlands and a few final details on the boat added wet-on-dry to the finished painting.

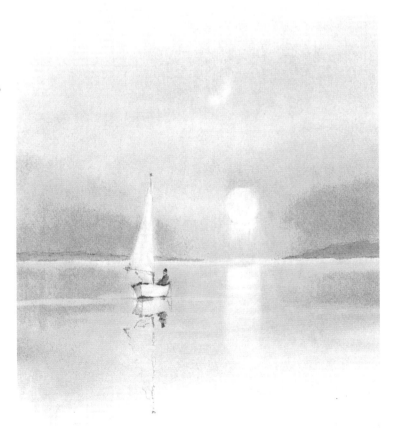

Overpainting wet-in-wet

You can apply more of the same colour or a different colour to a painted area while it is still damp to create darker tones. This is useful for defining shadows and contours. Each layer of colour should be allowed to soak in a little before applying the next, otherwise you risk disturbing the layer below and also creating a muddy appearance. A strong mixture is easier to apply and control than a weak one, which may cause stains and backruns, so ensure your brush is damp and not dripping wet before loading it with paint. Correctly applied, the paint should gently blend into the previous layer. If the mixture is too watery it may actually dilute the previous layer, causing a light patch to appear.

▼ *This quick sketch was mostly painted wet-in-wet, giving it a loose appearance.*

▶ *Overpainting wet-in-wet when the paper is still slightly damp retains the varied shading that emphasizes the curved shape of the large pot. On the flowerpots, however, the colours were applied too soon, merged together too much and look bland and muddy. The tonal variation and the texture is also lost.*

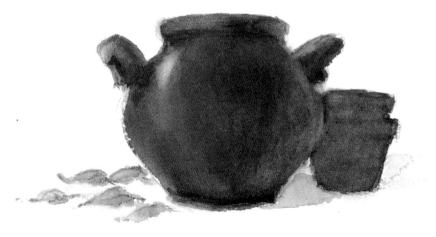

Lightening a painted area

There may be occasions when it would be beneficial to have a highlight to contrast with a dark area of colour. For example, a light streak on a shiny container, or a misty sun peeping through low morning clouds. Instead of attempting the risky business of dabbing out parts of a painted area with tissue, it is possible to create highlights just before the paper surface dries by lifting out colour with a damp brush.

To do this dip your brush into clean water and squeeze out the surplus using kitchen roll. This will leave the brush 'thirsty' enough to pick up colour from the paper in a controlled fashion. If the brush is too wet excess water may spread the paint rather than lift it out. For a light streak on dark water, stroke a damp flat brush sideways in one movement, then lift from the paper.

WET-IN-WET SUMMARY

FACT If you apply a strong mixture of wet paint to a damp surface you will get soft edges. If the mixture is too weak or applied too soon, the paint will be uncontrollable.

FACT Blending colours into each other while the surface is still damp produces soft-edged blends of darker colour. Blending in the colours too soon makes them merge and look bland or even muddy and may lift the colour instead of darkening it.

FACT Pulling a 'thirsty' brush across still damp paint lifts the colour to leave a light band.

FACT Using the brush too wet makes it difficult to control, causing stains and backruns.

▼ *While the tree reflections are still damp, the thin edge of a 'thirsty' flat brush can be pulled across the paint to remove colour and create a lighter horizontal streak.*

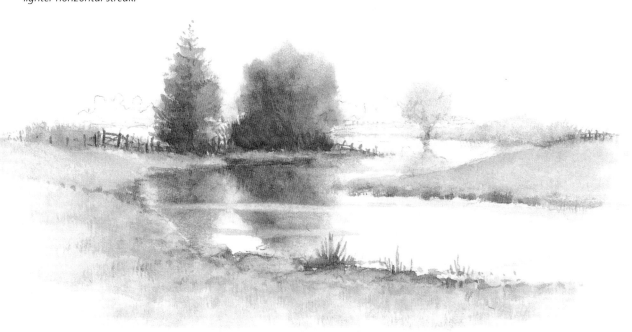

Tonal contrast

Your watercolour paintings will have far more impact if you learn how to create the illusion of depth through tonal contrast.

In my back garden there is a single tree, a hedgerow and a cluster of distant trees and if someone new to painting wished to paint this scene they would probably reproduce it just as it appears. The painting would probably have all the foliage painted in a similar shade of green and the result would look flat and boring. The lack of variation in colour and tone would make it hard for the viewer to separate the areas.

On a misty morning the distant trees appear lighter in tone and paler in colour, so the single tree in the foreground stands out more. You can use the same principle of contrasting light objects against dark to improve your work. On a sunny day the warmer, stronger tones of the single tree make it prominent against the paler background trees. So, by varying the lightness or darkness of a particular area in your painting or

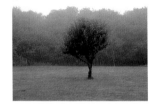

▲ *The mist makes the darker tones of the foreground tree appear to stand out against the lighter trees in the background.*

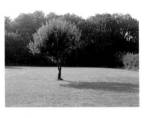

▲ *The warmer, stronger tones of the foreground tree contrast well with the paler, cooler colours of the background trees.*

making some areas more strongly coloured, one part can be made to stand out from another, giving the feeling of depth. This variation is known as tonal contrast. By exaggerating this effect the elements can be separated to give a three-dimensional look.

Practise this using a strong single colour such as French Ultramarine or Burnt Umber to make a monochrome sketch of your chosen scene, varying the tones to create depth. Use your tonal sketch as a guide for your finished painting.

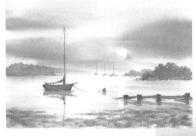

▲ *A sketch painting in one colour – French Ultramarine was used here – helps you to decide the tonal value needed in each area and this can be a useful guide in producing a finished work.*

▼ *AT ANCHOR*
38 x 56 cm (15 x 22 in)
Converting the tonal sketch into a finished painting in
full colour ensures that the tonal variations between each area are given adequate consideration.

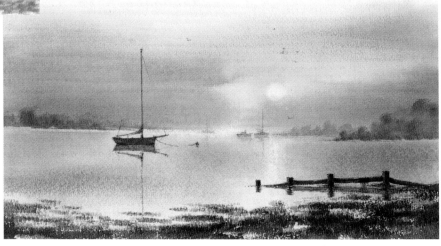

Improving tonal contrast

Even when paint is dry it is still possible to lighten certain areas to improve tonal contrast. Simply damp the selected area with a little clean water and allow it to soak in to activate the paint. After a short while, take a stiff hog bristle brush and gently tease out the required amount of colour. Clean the brush frequently and recharge it with clean water as required. For a large area you may find it easier to damp the whole painting with a large brush before starting to lift out colour.

<div style="border:1px solid;padding:1em">

TONAL CONTRAST SUMMARY

FACT If you paint a scene exactly as it appears it will look flat because the colours and tones are too similar.

FACT A one-colour sketch using a variety of tones or values for different areas will help you understand depth. Placing light areas against dark and dark against light creates the illusion of three dimensions.

FACT Cool colours recede. Warm colours advance.

FACT You can lighten dried paint to improve tonal contrast by removing some of it using clean water and a hog bristle brush.

</div>

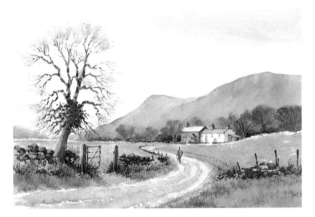

◀ *The mountains and distant tree line are very similar in tone and this is a little confusing to the viewer.*

▼ *After damping the paper, colour has been lifted from the far mountains. Now the increased tonal contrast makes the mountains appear further away and the band of trees stand out more prominently.*

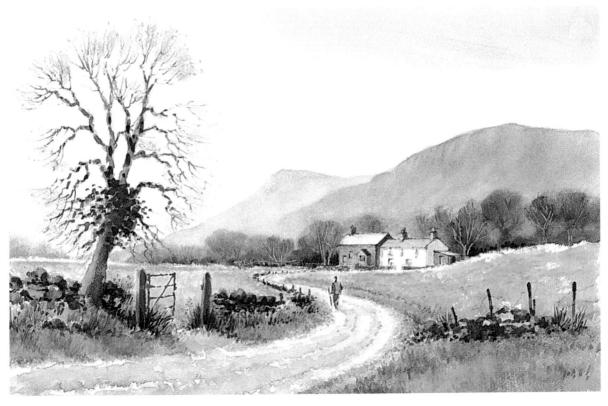

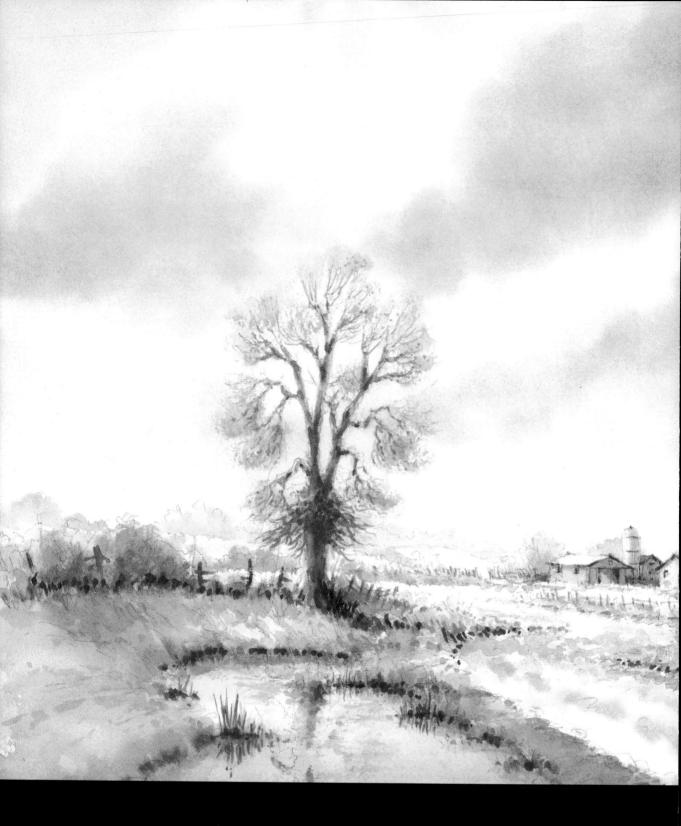

S

◀ *R O A D T O T H E F A R M*
37 x 56 cm (14½ x 22 in)
A low-level view accentuates the big sky and the vast expanse of open country. The diagonal movement of the clouds echoes the shape of the track, which, in turn, leads the eye into the scene – a useful ploy to unify a painting.

For most landscape painters the sky is one of the first areas to tackle, so it can make or mar a painting at an early stage. For the beginner, painting the sky should be seen as an opportunity to use large brushes and a loose approach, which is a good habit to acquire. The sky should complement the scene below, so a busy landscape might benefit from a simple sky and a simple scene may be transformed by using a low-level viewpoint and a spectacular array of clouds.

The duffer tends to be overanxious, using tiny brushes and dabbing them repeatedly onto the paper rather than using smooth, sweeping, economical strokes, and fails to wait for the optimum moment to apply colour or water. The results are messy, muddy blobs of colour, unwanted hard edges and unsightly stains and backruns. With a little forethought and practice these problems can easily be overcome.

MPLE SKIES

Graduated skies

One of the most simple methods for painting the sky and for suggesting depth in a scene, a graduated sky can be painted wet-on-dry but it is easier to paint wet-in-wet. This works even better if your board is tilted slightly to assist the downward flow of the paint.

exercise

■ Damp the paper first with clean water, using a large brush to ensure quick and easy coverage.

■ While this is soaking into the paper, make a strong mixture of French Ultramarine. The dampness of the paper will lighten the colour as your brush moves down the paper.

■ When the damp paper surface has dulled a little, take a large flat brush and pull a bold stroke of colour across the top of the paper in one continuous smooth sweeping movement.

■ Immediately pull a second brush stroke across, slightly overlapping the previous one. Now weaken the paint mixture by adding some more water.

Do this by pulling out a little of the strong colour on the palette and add water to this, rather than diluting all the paint.

■ Leave a tiny gap and stroke in some of the lighter blue. This stroke need not reach across the whole width of the paper.

■ Leave another small gap and pull some narrow streaks across from the other side of the paper. The paint should gently spread and blend into the damp surface of the paper, becoming lighter towards the horizon. Avoid touching the paint once it is applied or dabbing with tissue as this will take away the freshness and the dabbing may mark the paper.

▶ *For a simple graduated wash, blend a strong blue mix into the top of the damp paper. Add more water to lighten the colour towards the horizon. Leave a few gaps for added interest.*

brush movement ➡

▲ *Use long, sweeping horizontal strokes with a large brush to lay down a graduated wash.*

Cloud shapes

The duffer draws and paints clouds without thinking about composition and the results often resemble puddings or doughnuts – too similar in size, lacking variety in shape, and painted too wet, so the colours blend to form muddy blobs.

exercise

■ Arrange various size objects (for example, sponges or pieces of card or paper cut to shape) to form an interesting composition that is balanced and pleasing to the eye. First, try a simple combination of large, medium and small – you can vary this later.

■ Overlap the medium object with the small one to balance a separate large object – overlapping or interlocking shapes are more interesting than separate ones. It will soon become clear to you which arrangements work best.

■ Rough the composition out on paper to assess its effectiveness. You may find that leaving a hole in the largest shape improves the balance.

▲ *An easy way to avoid unvarying clouds is to arrange a series of everyday objects into an interesting formation, then use this as a guide. A small collection of natural sponges can be quite useful for this purpose, although cut-out pieces of card or paper would also suffice.*

▼ *The duffer's clouds are boring and repetitive. They are too similar in size, shape and tone.*

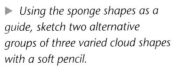

▶ *Using the sponge shapes as a guide, sketch two alternative groups of three varied cloud shapes with a soft pencil.*

Painting simple clouds

Although clouds appear soft and nearly transparent, they do have form, so paint variations in tone to suggest this. Often a large cloud is made up of many smaller sections that merge together. Also, they are not simply grey, but contain a wealth of different colours.

exercise

■ Use three primaries to create the required blue/grey colour instead of a ready-mixed grey.

■ For soft-edged clouds, damp the sky area and, using a medium round brush or small squirrel mop, apply a very pale wash of Raw Sienna over the cloud shapes. Leave small gaps for added interest.

▼ *Paint clouds wet-in-wet with varied tones of blue-grey mixed from the primaries to emphasize the form.*

■ Just before the paint dries, use short curved strokes to blend in a touch of Cadmium Red or Alizarin Crimson, leaving a light edge at the top and to one side of each cloud segment.

■ Pull some French Ultramarine into the red mixture on your palette and add a little more Raw Sienna. Blend this in to create shadow areas, leaving the yellow and red showing through in places. If you apply the final layer too soon it may result in a muddy look, so wait for the earlier layers to be almost dry before applying the final layer. Make sure the final blue/grey colour dominates, rather than red. Lighten a few small areas to add more form if required, using a thirsty brush.

Dramatic clouds

Dramatic clouds need to be drawn as dynamic shapes to suggest speedier movement across the sky. Use a mixture of Burnt Sienna and French Ultramarine to achieve various tones of blue/grey – this is easier to mix than the three primaries.

exercise

▼ *Apply a simple mixture of Burnt Sienna and French Ultramarine wet-in-wet to create various tones of blue/grey for dramatic clouds.*

■ Using a soft pencil, rough in an interesting cluster of clouds, ensuring they are varied in size and shape. Damp with clean water.

■ Mix a blue/grey by adding a little Burnt Sienna to French Ultramarine. Make sure that the French Ultramarine is more dominant than the Burnt Sienna, otherwise your clouds may have a brownish appearance. Apply a light wash of the blue/grey colour over the cloud shapes, leaving gaps here and there for added interest.

■ When the first wash is almost dry, blend in a stronger mix of the blue/grey colour, leaving lighter patches to suggest form.

■ To add more form, blend in even stronger colour in the lower areas.

Sky with fluffy white clouds

To suggest fluffy white cloud masses paint the blue sky around the edge of them, leaving the white of the paper to represent the cloud shapes. Soft-edged clouds look more natural than hard-edged ones, so use wet-in-wet technique.

exercise

■ Establish where your clouds are going to be, either by drawing a rough outline or by planning out the shapes on a separate piece of paper, then use this as a guide.

▶ *For a sky with fluffy white clouds, pull down Cobalt Blue around the cloud shapes and let it blend gently into the damp paper, leaving soft edges. The unpainted paper suggests the clouds.*

▶ *Use the side of the bristles flat to the paper to apply the colour.*

brush movement

■ Damp the complete sky area with clean water and allow it to soak in for a while.

■ Starting from the top of the paper, apply Cobalt Blue with a large round brush. Move the brush up and down, using the side of the bristles flat to the paper.

■ Stop applying colour short of the cloud shapes and allow it to blend gently into the damp paper, leaving soft-edged, unpainted areas to form the clouds. If the paint runs into the cloud shapes remove the excess by lightly pushing the paint back with a piece of kitchen roll. Do not dab, as that will mark the paper.

▶ *TIME TO GRAZE*
37 x 56 cm
(14½ x 22 in)
A peaceful scene with a horse grazing among the buttercups is given a lift by the billowing white fluffy clouds. The blue of the sky is painted wet-in-wet around the cloud shapes .

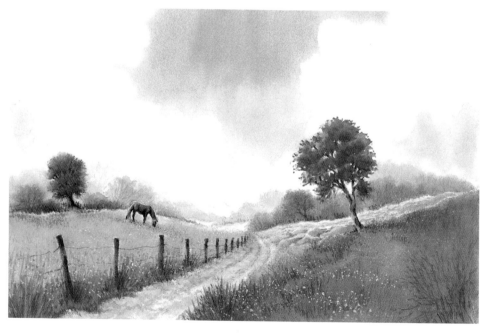

Sunset sky

Sunsets make very striking paintings, especially for coastal scenes. They are quite simple to paint using the wet-on-dry technique, which results in crisp edges to the sun, cloud edges and the land masses. Let each layer dry thoroughly before applying the next one.

exercise

■ Draw a horizon line and a circle above it for the sun. Using a large round brush or squirrel mop, apply a graduated wash of pale orange mixed from Lemon Yellow and Cadmium Red – a pale mix at the top, which is strengthened towards the horizon. Use long, sweeping, horizontal brush strokes. Allow to dry completely.

■ Mix a stronger orange from Cadmium Red and Cadmium Yellow and apply a second graduated wash over the first. Use horizontal strokes – not too smooth, as a few odd streaks will add to the effect. About halfway down, add more Cadmium Red and, just before you reach the circle, paint carefully round it and then blend the colour into your horizontal strokes. Continue to the horizon line to leave a neat edge. Leave a small gap before continuing to suggest the sun shining on the distant sea.

▶ *This simple sunset sky is painted in two layers, wet-on-dry, with the paper being allowed to dry between each layer. This makes it easy to paint a neat edge to the circular shape that represents the sun.*

brush movement

◀ *Long, sweeping, horizontal brush strokes are used except when painting around the sun on the second layer. Use a smaller brush for this if you find it easier.*

▶ *SUNSET AND LIGHTHOUSE*
25 x 33 cm (10 x 13 in)
This simple sunset is painted wet-on-dry, using just three colours – Lemon Yellow, Alizarin Crimson and Cobalt Blue. The first layer was painted light to dark over the sky, then dark to light over the sea. The blue was added to tone down the colour for the clouds, ripples and headlands.

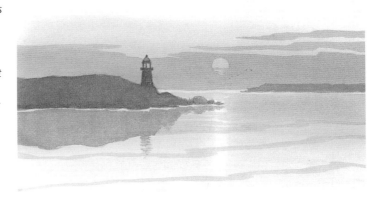

DEMO Windmill at Sunrise

COLOURS USED

Lemon Yellow

Raw Sienna

Cadmium Red

Cobalt Blue

Burnt Sienna

A misty sky can be the basis for a very atmospheric landscape and it is easy to create the desired effect using wet-in-wet techniques. The secret is to start with graduated washes of slightly muted (neutralized) colour over the whole painting and, when dry, to overpaint the detailed areas wet-on-dry.

step 1

I used a soft 3B pencil to draw the scene. Then I damped the paper all over. I mixed Lemon Yellow and Raw Sienna and, using the hake with horizontal brush strokes, painted a graduated wash light to dark over the sky and dark to light from the horizon downwards. Using a slightly stronger mix, I blended more paint over the land masses and the windmill. Just before this was dry, I used a thirsty brush to pull out the shape of the sun and vertical light streak on the water.

step 2

I damped the paper. I added Cadmium Red and a tiny amount of Cobalt Blue to the mix, then painted a graduated wash, light to dark above the horizon and dark to light below. Before it dried, using a stronger mix I pulled horizontal streaks into the lower sky and matching ones in the upper river. With an even stronger mix, I painted the land masses and windmill. I used a thirsty brush to lift out the sun, the streak on the water, a light strip below the horizon and the side of the windmill.

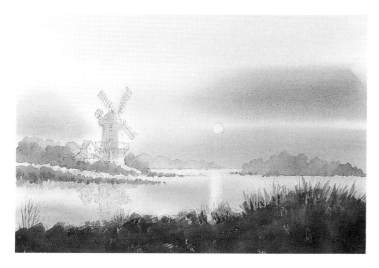

step 3

I allowed the paper to dry, added a little water to the mixture and used a size 8 round brush on its side to paint the distant trees. I strengthened the mixture, adding a little more red and blue plus a little Burnt Sienna, and used a squirrel brush to paint the nearer trees, banks, windmill and reflection, varying the tones as required.

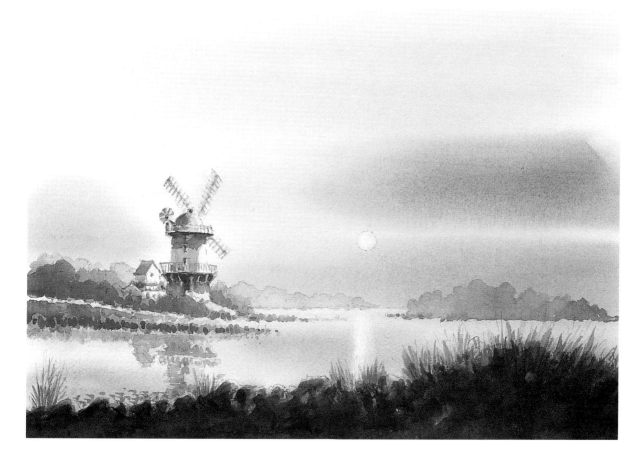

step 4

I added more red, blue and Burnt Sienna to make a strong mixture for detail in the trees, windmill and far riverbank. I strengthened the mixture again to darken the foreground, adding rough tufts of grass and a few rocks.

▲ *WINDMILL AT SUNRISE*
30 x 41 cm (12 x 16 in)

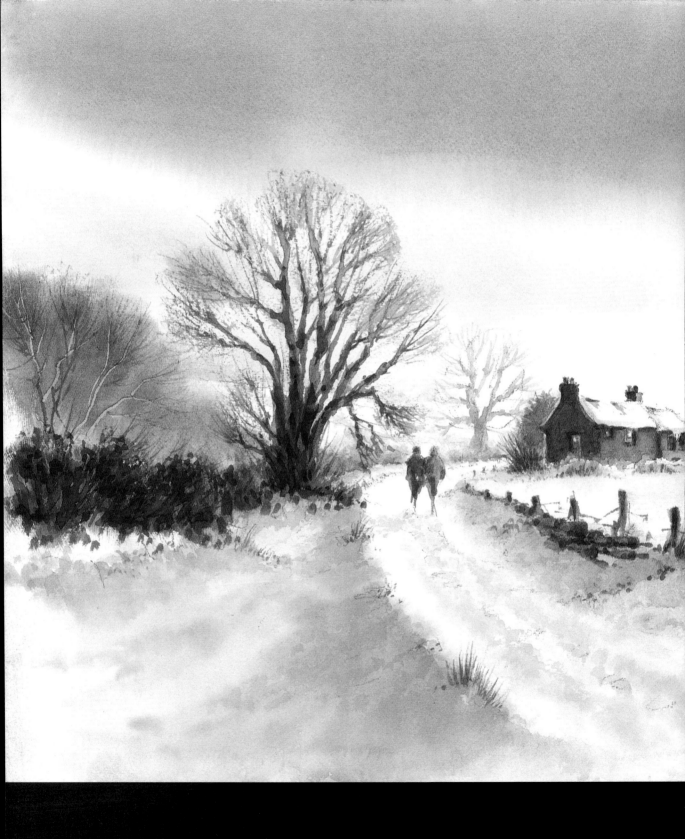

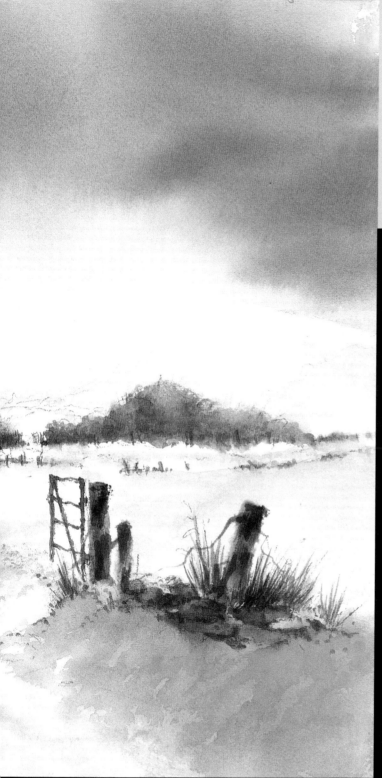

Painting winter scenes can be rewarding for many reasons. The trees are so much more interesting than in summer because you can see more of their structure and the sky is often dark and brooding, offering excellent opportunities to practise heavy graduated washes. The lower sun casts longer shadows and these can be used to emphasize the contours and convey the undulations of the land – in particular, the furrows and small clods of earth on a ploughed field or a rutted farm track.

Even a light dusting of snow can transform a dreary landscape and give it a magical quality. It is often difficult to paint on location in cold or wet weather, so photographs or quick sketches can provide the references you need to paint the scene in comfort at home. I often paint familiar views as imaginary snow scenes and this is an excellent way to expand your repertoire.

NDSCAPES

Distant trees

Distant trees are seen through layers of dust in the atmosphere, so colours appear pale and muted – usually light blue/green or blue/violet. They can be painted in various ways, so use whichever method you find easier. Remember not to make them too dark in tone.

exercise

■ Using a pale, but not too watery, mix of Cobalt Blue, lay a medium round brush on its side really flat to the paper so the sides of the bristles are in contact with the surface. Without lifting the brush away from the paper, and with an up and down movement, paint a ragged line of distant trees. It is important to vary the height and shape of the tree clusters.

■ Next, use a fairly dry pale blue/green mix of French Ultramarine and Lemon Yellow and a flat brush. Remove surplus paint on a piece of scrap paper and, holding the brush at an angle, use the corner of the bristles, pulling downwards in a dabbing motion to create a ragged top edge and baseline to the clusters.

■ Once again a flat brush is used with a pale blue mix of French Ultramarine. Wipe the bristles back and forth across the palette to flatten the brush, which forms a chisel edge to the bristles. Then hold it fairly flat to the paper surface. Press it onto the horizon line, then pull it briskly up onto the dry paper, lifting at the same time to form a ragged edge to the tops of the trees. Do not work over the area more than once or you may lift off the first layer.

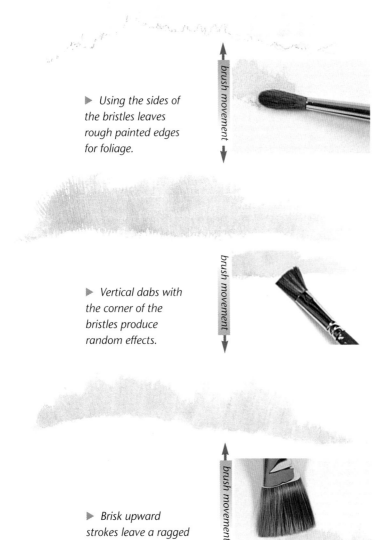

brush movement

▶ Using the sides of the bristles leaves rough painted edges for foliage.

brush movement

▶ Vertical dabs with the corner of the bristles produce random effects.

brush movement

▶ Brisk upward strokes leave a ragged top edge.

◀ As these three examples show, different brushes can be used in different ways to achieve the same effect – in this instance, ragged edges for distant trees.

Mid-distance trees and hedgerows

Paint trees and hedgerows together, using wet-in-wet technique and working from light to dark. Vary the height of the tree line and leave the tops of hedgerows light in colour and the base dark and ragged – remember they are not neatly trimmed garden hedges.

exercise

■ Start with a light underwash of Lemon Yellow mixed with Raw Sienna. Apply the colour with a flat brush pulled upwards onto dry paper, leaving a ragged edge along the top of the tree line.

■ Before the paint dries, blend in a touch of Alizarin Crimson in places. When this is almost dry mix Cobalt Blue with the Crimson to make a dulled violet and use this to add shadow areas and to suggest trunks and branches.

■ Add French Ultramarine and a touch of Burnt Umber to the mix and, with a medium round brush, use this stronger blue/grey for darker trees, branches and hedges. Add more of each colour to paint darker areas and shadows. For the hedgerows the paint mixture should be very dry. Paint them with a flat brush, using short vertical strokes.

■ Use a rigger to suggest finer branches and a palette knife to scratch out light trunks and branches from almost dry paint.

■ For the light foliage clinging to the branches use a pale yellow/brown mix of Raw Sienna with a touch of French Ultramarine and Alizarin Crimson added. Apply this with an up and down movement, using a medium round brush on its side, flat to the paper.

▼ *Build the colours up layer by layer, light to dark, to achieve the effect of varied foliage. Leave some of the lighter colours to show through in places.*

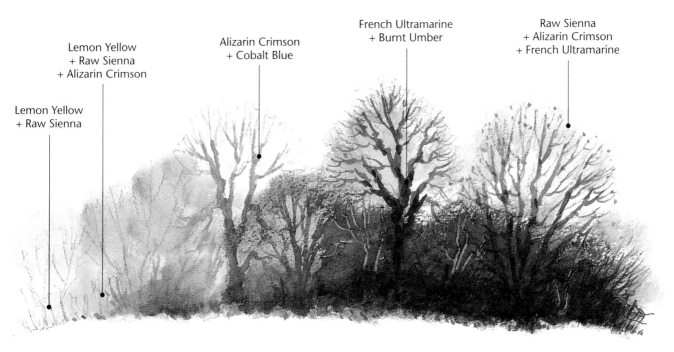

Lemon Yellow
+ Raw Sienna
+ Alizarin Crimson

Lemon Yellow
+ Raw Sienna

Alizarin Crimson
+ Cobalt Blue

French Ultramarine
+ Burnt Umber

Raw Sienna
+ Alizarin Crimson
+ French Ultramarine

Drawing winter trees

The branches of most trees zig-zag upwards and outwards towards the light in a series of slightly curved lines, repeatedly changing direction and getting progressively thinner. A common mistake is to make the upper branches thicker than the lower ones.

exercise

■ Mark the overall height of the tree. Indicate the ground level, using a ragged line. Draw the trunk a third of the total height, ensuring it is in proportion – not too wide for the height of the tree, not too thin and straight and not tapering in at the top. Draw a faint ragged guideline to suggest the outer shape of the tree. Avoid making it too even in shape. Now draw two rough 'V' shaped guidelines from the top of the trunk to show the position of the main branches. Divide the width of the trunk at the top into two and extend the two halves of the trunk upwards and outwards as two thick branches, rather like the 'Y' shape formed by extending your forefinger and thumb. Make the inner part of each slightly longer than the other and do not splay them out too far.

■ Divide each branch into two again and extend further branches in the form of 'Y' shapes from them. The extended branches will be half the thickness of the previous branches each time, with the longer branch nearest to the centre of the tree.

■ Continue the process upwards and outwards. Draw a few thin stems out to the guideline for finer branches.

■ To fill the centre of the tree draw a stem half the width of the existing branch for a short distance, then split it into two and extend two branches to form a further 'Y' shape. Repeat this on one of the branches just above the main trunk – in this case extend a branch sideways and downwards to form a dangling section of branches.

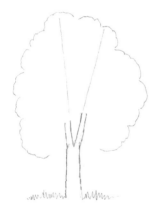

▲ *Use simple guidelines to show the outer shape and trunk of the tree. Divide the trunk at the top.*

▲ *Extend the main branches using a 'finger and thumb' shape, then add further branches.*

▲ *Pull out finer branches to the outer guideline.*

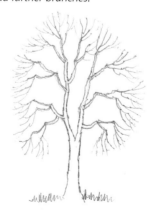

▲ *Fill gaps with additional branches to complete the tree.*

Painting winter trees

Winter trees make great subjects for paintings. The bare branches allow you to see the structure clearly. Avoid the temptation to show trees as silhouettes, but paint them with shaded areas to emphasize their shape and depth.

exercise

■ Using a medium round brush, apply a light wash of Lemon Yellow and Raw Sienna to the trunk and main branches. Add a little Cadmium Red to the mixture and blend it into the still damp paint, leaving some of the previous layer showing through.

■ Before this dries blend a dull violet colour from Cadmium Red and Cobalt Blue into the trunk and main branches, again leaving some of the earlier colour showing.

■ Add French Ultramarine and Burnt Sienna to darken the mixture and apply this to the shadow areas where the branches split. Also add a vertical band of shading just off-centre down the trunk, blending it in to emphasize the roundness.

■ With the same mixture use a rigger, after first removing surplus paint from the brush on a piece of scrap paper, to pull out fine branches to the outer guideline. Leave gaps here and there or the tree will look too formal.

■ Again using the rigger, dot in a few random leaves over the finer branches and, if required, darken the mixture a little to emphasize the shadow areas.

■ Apply a sparse amount of dull yellow foliage over the finer branches with a medium round brush, using the side of the bristles. Allow to dry a little, then add darker colour as shading.

◀ *The colour is built in progressive layers.*

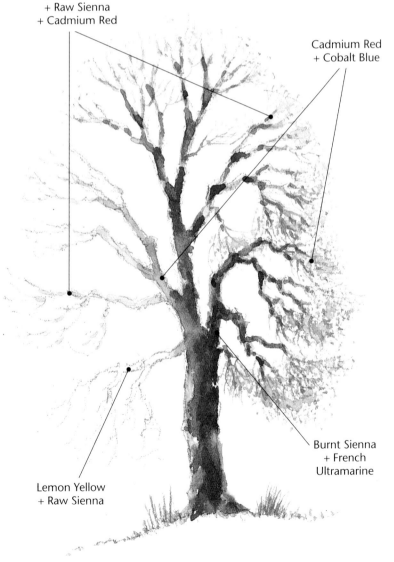

Lemon Yellow
+ Raw Sienna
+ Cadmium Red

Cadmium Red
+ Cobalt Blue

Burnt Sienna
+ French
Ultramarine

Lemon Yellow
+ Raw Sienna

Firs and pines

Evergreen trees such as conifers can enhance your landscapes. They are particularly effective in snow scenes. A big mistake is to paint them too fussily and attempt to put in every branch – just a suggestion of finer branches here and there will do the trick.

exercise

■ Using the side of the bristles on a medium round brush (say, a size 5), or a small squirrel brush, flat to the paper, and with up and down strokes, paint a band of pale Lemon Yellow, leaving ragged edges top and bottom.

▼ *Apply Lemon Yellow and Cobalt Blue using a medium round brush, keeping a ragged edge top and bottom. Blend in Cadmium Red.*

▼ *Add French Ultramarine. Darken the foliage and add trunks.*

▼ *Add Burnt Sienna to darken the mixture to complete the foliage. Darken the mixture again to add shading.*

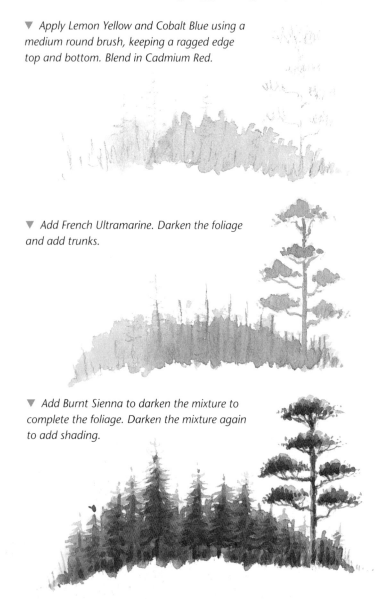

Use the same technique to paint the foliage on the tall pine tree. Pull some Cobalt Blue into the Lemon Yellow to make a pale blue/green mixture and add a very tiny amount of Cadmium Red to dull the colour. Blend this into the almost dry first layer wet-in-wet, leaving some of the yellow showing.

■ Darken the mixture further with French Ultramarine and blend in a darker strip of colour along the base of the tree line. Then, shaping the brush to a point, pull up more thin lines to suggest trunks. Add the trunk and main branches to the pine tree.

■ Using the same mixture, a rigger and a light touch, paint sweeping lines of foliage over the trunks of the fir trees, using a swinging, 'left-right' pendulum motion. Where the brush strokes meet the original band of colour, the paint will blend, leaving shadowy shapes. As this dries, darken the mixture further by adding more French Ultramarine and some Burnt Sienna. Apply this to one side of the individual trees to create shadow areas and overpaint the larger lower branches with curving brush strokes. Emphasize the lower trunks with this dark colour. Add finer branches to support the foliage on the pine tree and add darker shading and a few random leaves to the foliage.

Birches

In winter and spring birch trees are often a glorious shade of red/violet and their light-coloured trunks and branches really stand out well against darker background trees. The fine light branches can be left as unpainted paper or pulled out of almost dry paint.

exercise

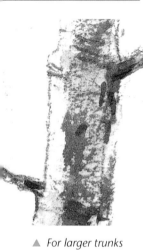

■ Mix a slightly dulled deep pink using Alizarin Crimson with a touch of Burnt Sienna and pull this upwards from the ground level with a flat brush. As you lift the bristles they should leave a rough edge to the top of the tree line on the dry paper.

■ Strengthen the mixture with a touch more of each colour and a tiny amount of Cobalt Blue. Blend this in before the first layer dries, leaving some of the first layer showing through in places.

▲ *For larger trunks paint the shadow side with Cobalt Blue and overpaint texture and branches by adding Alizarin Crimson and Burnt Sienna.*

■ Before the second layer dries completely, use a palette knife to pull out some light trunks and a few finer branches. Do this with firm, but ragged, strokes.

■ When dry, add more Cobalt Blue, Burnt Sienna and a little French Ultramarine to the paint mixture. Use a medium round brush (say, a size 5) to indicate dark trunks and use a rigger to paint the finer branches.

▼ *Build the colours using mixtures of Alizarin Crimson, Burnt Sienna, Cobalt Blue and French Ultramarine. Pull out light trunks using a palette knife.*

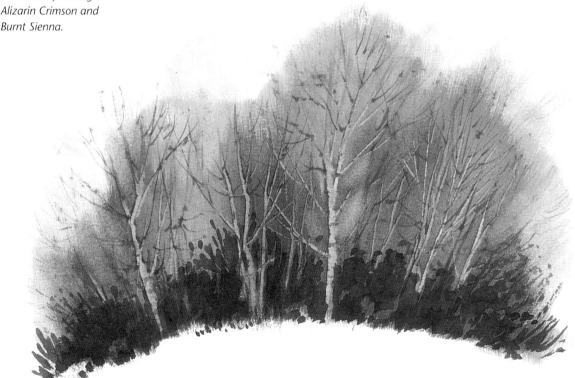

Drawing figures

Many artists experience difficulties when drawing people in landscapes, and my solution is to use simple shapes as a guide to drawing the figures. The size of your figures should be in proportion to the rest of the painting, so relate them to the objects around them.

exercise

■ The duffer draws figures that are usually rigid in shape with square shoulders, large heads and large feet. By observing people more closely you will notice that heads are not round and positioned upright on the body like cabbages on poles. They are more oval in shape and, seen from the side, the head sits on the neck at a slight angle. At a distance, from the front and rear, the head appears to blend into the shoulders.

■ Drawing trellis-shaped guidelines makes it easier to draw figures. 'Trellis man' has a small head, a large upper body and a medium-size lower body, so the trellis shapes reflect this. 'Trellis woman' has a small head, a medium-size upper body and a larger lower body (use this only as a rough guide!).

■ After drawing the basic shapes, it is a simple matter to convert them into people by adding clothes and hair. This is where sponge shapes can be helpful by superimposing them over the trellis shapes to fill them out. It is essential to keep the heads small and leave out any suggestion of large shoes or feet. Ensure the legs do not splay out, but are fairly close together and taper to nothing.

▼ *Trellis shapes make ideal guides for drawing figures (below left). Another way of drawing people is to overlay sponge shapes on the trellis guides (below). A small one suggests the man's head, a large one the upper body and a medium one can be used for the lower body. The woman has a small one for the head, a medium size for the upper body and a large shape for the lower body.*

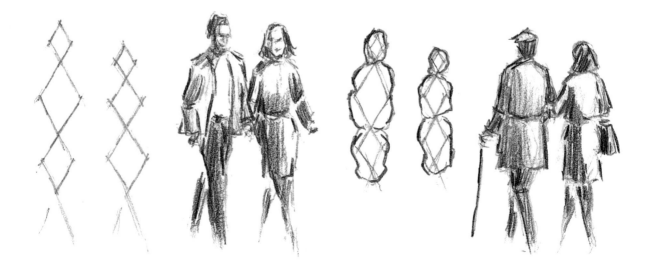

Painting figures

Figures need to look realistic and in proportion to the rest of the painting. The colours should be in harmony with the scene and not look garish. Try to keep the figures loose rather than detailed and show them in action if possible.

exercise

▲ *Paint a yellow underwash over the entire figures.*

▲ *Blend in a little Cadmium Red in places and build up the colours gradually wet-in-wet.*

▲ *Use a grey mixed from French Ultramarine and Burnt Sienna to add finishing touches and shading.*

■ Mix a light wash of Raw Sienna and, using a size 5 medium round brush, paint both the figures. Suggest the shapes loosely with a few brush strokes, so do not be too fussy. Before the colour dries out completely, blend in a little Cadmium Red here and there, especially on the heads.

■ Build up the colours to suit the subject – perhaps a dark green outfit for the lady and dark blue trousers and a brown coat for the man. Blend in the colour before the previous one dries to achieve the effect of shadows and shading and to give shape and form. For the legs or trousers, use brisk downward brush strokes that fade away to nothing rather than painting shoes or boots.

■ Mix a dark blue/brown from Burnt Sienna and Cobalt Blue for the hair of the man and touch this onto the back and top of the head, again using a quick brush stroke and no detail, leaving the face showing on one side. For added effect paint a cap or hat, or even a walking stick or umbrella. For the lady, add perhaps a hint of red/brown (Burnt Sienna) on the shadow side. To add the final detail use a mixture of French Ultramarine and Burnt Sienna to add shading on one side of the body, below the sleeves and on the half-hidden leg – just a few touches will bring the figures to life. If the sun is shining you will need to paint shadows on the road away from the sun to match the surface of the road or lane.

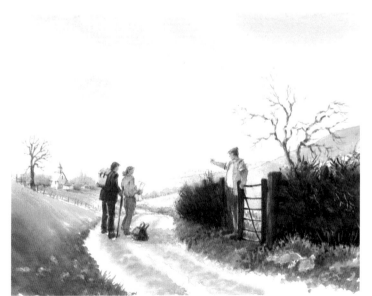

◀ *THE WAY AHEAD*
27 x 34 cm (10½ x 13½ in)
It is always helpful for the figures in your painting to be doing something. Here, the position and attitude of the people tell their own story.

DEMO Icy Journey

COLOURS USED
Lemon Yellow
Raw Sienna
Cadmium Red
Alizarin Crimson
Cobalt Blue
French Ultramarine
Burnt Sienna

Reproducing a snow scene just using the unpainted paper to suggest the highlights on the snow can be very satisfying. This is an opportunity to practise winter trees and placing figures to give a focal point. Even in a snow scene I paint a pale underwash to shine through the subsequent layers and unify the painting.

step 1

I used a soft 3B pencil to draw the basic land masses and to suggest the trees, hedges and figures without too much detail. After damping the paper all over I painted a pale underwash of Lemon Yellow and Raw Sienna wet-in-wet over the cloud shapes, the main land masses and the trees and hedges, leaving plenty of light unpainted areas. Before this dried I added a touch of Cadmium Red to the mixture and blended a touch of warmer colour to the foreground areas and the hedgerows.

step 2

I damped the sky area with clean water down to the distant line of hills, taking it right over the trees. While this soaked in I mixed Alizarin Crimson and French Ultramarine and added a tiny amount of Burnt Sienna to neutralize the colour. Then, using a large hake, I used curved brush strokes to paint the large cloud shapes, leaving gaps between them. The slope of my board ensured that the paint was a little darker in the lower part of each cloud shape.

step 3

I damped the snow-covered area and allowed this to soak in. Using a large round brush, I blended Cobalt Blue into the damp paper, matching the brush strokes to the terrain to suggest the undulations and leaving gaps here and there for the highlights. Before this dried I added Alizarin Crimson to the Cobalt Blue and used this violet colour to strengthen the shadow areas. Then I added a touch of French Ultramarine to darken the mixture still more to paint the darker shadows.

step 4

Using the side of the bristles on a medium round brush, I painted the distant tree line using a little of the diluted snow colour. I added a tiny amount of Burnt Sienna to darken the slightly nearer tree line. I used a small squirrel brush and a pale wash of Lemon Yellow and Raw Sienna to paint the mid-distance trees and hedges, and blended a touch of Cadmium Red in here and there. I added more Cadmium Red and Cobalt Blue to the mixture to paint darker shadows in places.

step 5

I used the same colours – Lemon Yellow, Raw Sienna, Cadmium Red and Cobalt Blue – to paint the foreground hedgerow, the tree and the figures.

step 6

Next, I mixed various shades of Alizarin Crimson, Cobalt Blue and Burnt Sienna to put more strength into the mid-distance tree line, using the side of the bristles on a small squirrel brush for the rough foliage and a rigger to paint the trunks and branches. I tried to avoid too much detail.

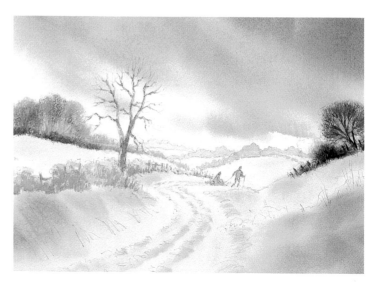

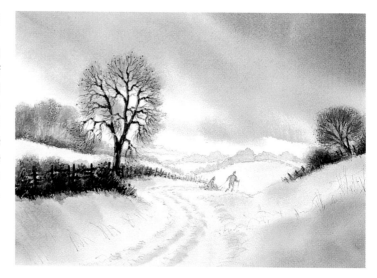

step 7

With a mixture of Cadmium Red and Cobalt Blue, I darkened the trunk and branches of the large tree and started painting the foliage using a small squirrel brush. I added Burnt Sienna and French Ultramarine to darken the mixture and blended this in to suggest heavier shadow. I used the same mixture and a rigger to pull the finer stems into the foliage and dotted in a few odd leaves.

step 8

To complete the foreground hedge and fence I overpainted a light wash of Lemon Yellow and Raw Sienna and blended in a touch of Cadmium Red in places. Before this dried completely I touched in a dry mixture of Cobalt Blue and Cadmium Red here and there before adding Burnt Sienna and French Ultramarine for the dark shadows.

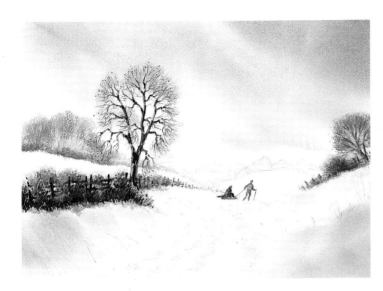

step 9

I used a mixture of Cadmium Red and Burnt Sienna to paint the man's sweater, the sled and the lady's hair, and French Ultramarine and Burnt Sienna for the man's trousers. Lemon Yellow was added to French Ultramarine for the lady's coat.

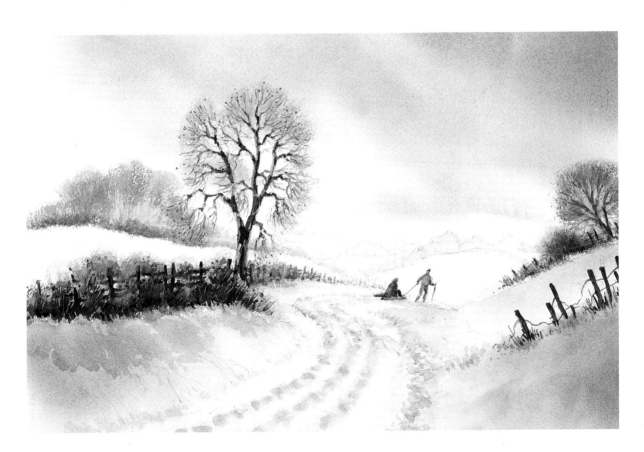

step 10

I damped the snow and blended in shading using an Alizarin Crimson and French Ultramarine mix, adding Burnt Sienna for the darker shadows. I used the same mix with more Burnt Sienna and blue to paint the fence posts.

▲ *I C Y J O U R N E Y*
30 x 41 cm (12 x 16 in)

SUMMER I

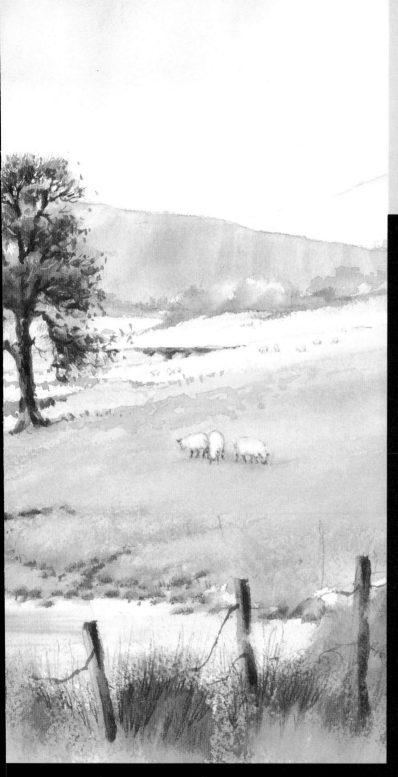

Trees, rivers and bridges are essential elements of many summer landscapes. For most new painters and even some experienced artists, painting trees in particular is a source of great anguish. There is no real excuse for painting trees that look unrealistic since they are a ready subject. Most of us see trees every day and are able to observe them.

Since summer trees are laden with foliage it is all too easy to paint them with little variation, using similar greens and poor contrast between the different areas in the painting.

Bridges and rivers, too, are both popular subjects that are frequently cruelly mistreated by many amateur painters. Rivers running uphill, lop-sided bridges and misplaced reflections are commonplace painting errors.

The solution to these problems lies in using a logical approach and the following exercises should help you on your way.

ANDSCAPES

Mid-distance trees and hedgerows

Distant trees, hedgerows and bushes appear pale blue because they are seen through the dust in the atmosphere, so the techniques for painting them are the same as those described on pages 44 and 45 for winter trees. The nearer, mid-distance trees are warmer in colour.

exercise

■ Draw a rough outline to show some mid-distance clusters of trees, varying the height and shape.

■ Build the colour step-by-step, starting with a light yellow background wash of Lemon Yellow and Raw Sienna. Brush the foliage in loosely using the side of the bristles of a medium or large round brush to suit the size of the painting.

■ Just before the first layer dries, overpaint wet-in-wet, first with Cobalt Blue, then with darker greens mixed by adding French Ultramarine and Cadmium Yellow for variation and to indicate shadows and shading.

■ Add some Burnt Sienna to the mixture to paint a few darker trunks and branches here and there, but try to avoid painting branches over the top of foliage. Scrape out lighter trunks and branches using a palette knife. Add more French Ultramarine and Burnt Sienna to paint the darker shadows under the hedge.

▼ *Allow the initial light wash to show through subsequent layers to enliven your band of trees.*

Lemon Yellow
+ Raw Sienna

Lemon Yellow
+ Cobalt Blue

Lemon Yellow
+ French Ultramarine

Cadmium Yellow
+ French Ultramarine

Burnt Sienna
+ French Ultramarine

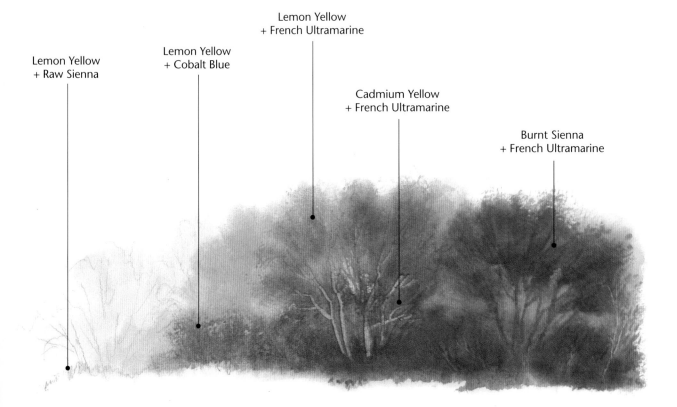

Form in tree foliage

As with clouds (see page 35) you can use different size sponge shapes as a guide to drawing random shapes for clumps of foliage. When you have achieved a balanced composition, decide the direction of the light source, then apply shading to give form to the clumps.

exercise

■ With a soft pencil laid flat to the paper and using up and down strokes, draw three random shapes – one large, one medium and one small – arranging them as a balanced cluster. Overlap the shapes of the foliage for added interest if you wish.

■ Add slightly darker shading to one side – that is, the side away from the source of light – and also darken the lower part of each shape.

■ Then add even darker shading to these areas, leaving some of the second layer showing. You will find that the three flat shapes suddenly appear to have form and body.

■ Draw in a trunk and connect the shaded areas by inserting branches in the gaps. Then add a few random leaves at the edges of the clusters and you will now have a reasonable drawing of a tree. If you can accomplish this in a drawing, it should not be difficult to create a similar effect with paint to produce a summer tree. Read on!

▶ *Use a soft pencil to sketch three random shapes.*

▶ *Darken the bottom and one side of each shape.*

▶ *Add even darker shading to give added moulding to the shapes.*

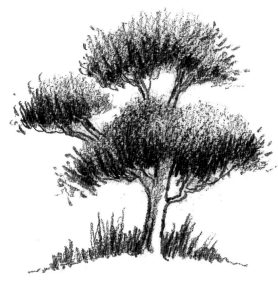

▲ *Add trunk, branches and random leaves to form a tree.*

Drawing summer trees

The duffer draws summer trees that usually look distinctive, but rarely look realistic. Some duffers even paint branches over the foliage – no marks for these! To avoid elementary mistakes try the following simple methods to produce shapely trees with added depth.

exercise

■ Draw a ragged line to show the ground level and mark the overall height of the tree. Draw the main trunk in proportion to the height of the tree and a rough outline to show the outer limits of the foliage.

■ Divide the top of the trunk in half and extend two sections of branch in the form of a 'Y' shape, then draw a couple of 'V' shaped guidelines to show the position of the branches.

■ Arrange random-shaped clusters of foliage within the outer boundary line in the same way that you arranged the sponge shapes on page 59, leaving a little space between the clusters for the branches to show through.

■ Insert branches in the gaps between the foliage clusters, roughly following the guidelines. Try drawing a range of different tree shapes for practice.

▶ *A variety of different tree shapes can be drawn using the same method.*

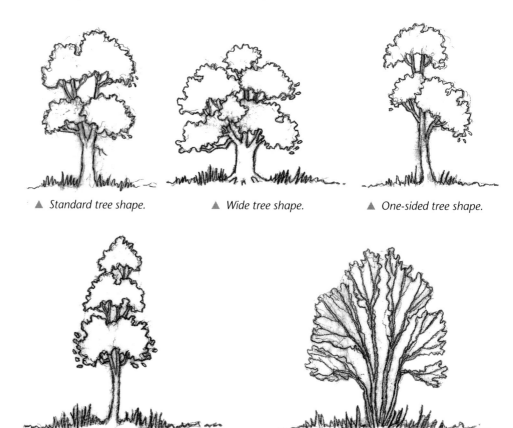

▲ *Standard tree shape.* ▲ *Wide tree shape.* ▲ *One-sided tree shape.*

▲ *Slim tree shape.* ▲ *Multi-trunk tree shape.*

Painting summer trees

Your paintings will lack conviction if you paint trees as flat objects with no depth or with branches painted on top of the foliage. The way to avoid this is to adopt the same routine with colour as you did using three layers of pencil shading to sketch foliage on page 59.

exercise

■ Mix a light wash of Lemon Yellow and Raw Sienna and paint clusters of foliage using a medium round brush laid flat to the paper. Move the bristles up and down to achieve ragged-edged shapes, then add the trunk and branches using the same colour.

■ Pull some Cobalt Blue into the yellow mixture to make a light green. Apply to the foliage before it dries, leaving some light colour showing through on the tops and sides of each cluster closest to the light source.

■ Mix Lemon Yellow and French Ultramarine to make a stronger green to add darker shading to the foliage clusters. Pull some more French Ultramarine and a tiny amount of Burnt Sienna into your paint mixture to darken the green. Apply this first to the trunk and branches, leaving some of the previous layer showing through in places. Work some more into the foliage clusters as shading. Dot a few random leaves in near the edges of the tree clusters, using this same dark mix, to complete the painting.

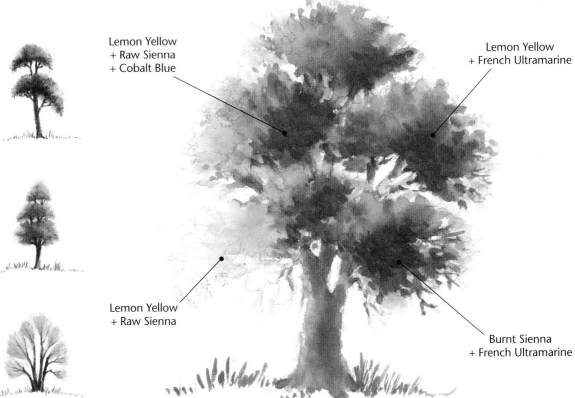

Lemon Yellow
+ Raw Sienna
+ Cobalt Blue

Lemon Yellow
+ French Ultramarine

Lemon Yellow
+ Raw Sienna

Burnt Sienna
+ French Ultramarine

Drawing bridges

A bridge always makes an interesting focal point, especially one with a distinctive arch and matching reflection. I usually draw rough guidelines, then draw the bridge freehand. If drawing a bridge is a problem for you the following method of construction may help.

exercise

■ Imagine you are looking at a bridge and its reflection from a boat on the river. Draw the banks, the distant horizon and a dotted horizontal line at water level. Draw the top of the bridge roughly parallel to the waterline and, at an equal distance below, a line to show the reflection of the top of the bridge. Draw the river bank reflections as ragged lines.

■ Draw a vertical broken guideline to indicate the centre line of the bridge and centred on that and the waterline, box-shaped guidelines. The top of the box will mark the height of the arch above the waterline and the bottom of the box – an equal distance below the waterline – will show the depth of the reflection. The sides of the box show the positions of the sides of the arch – from this angle they are an equal distance from the centre line.

■ Using the box shape you have drawn, it is a simple matter to draw a suitable matching curve across each corner to form the arch and its reflection – which in this case is a complete circle.

■ If we assume that the boat is moored a little to the left of centre you will need to draw two further curves on the right-hand side to show the dark shadow of the underside of the arch and its matching reflection. It is important that the top of this curve does not extend beyond the centre line because, as your eye level is above the waterline, the underside of the centre of the arch cannot be seen from your vantage point, although its reflection may be visible in the water below. The further you are from the centre of the bridge the more of the width of the arch will be visible.

▶ *To establish the symmetrical shape of an arch and its reflection use box-shaped guidelines.*

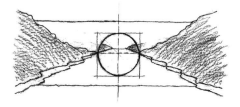

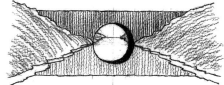

Painting bridges

Since most bridges are constructed of stone or brick it is tempting to paint them with a simple wash of grey or light brown. They can look more interesting if the colour is built up in stages to give a variety of tones, colours and textures.

exercise

■ Use a medium round brush and a pale mixture of Raw Sienna to paint the whole bridge including the arches and the reflection. Before this dries completely, blend in a little Cadmium Red wet-in-wet.

■ Pull some Cobalt Blue into the red on the palette and, before the last layer dries completely, blend this violet

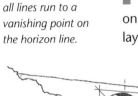

▼ *From an angle all lines run to a vanishing point on the horizon line.*

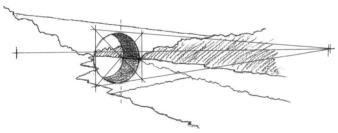

mixture onto the drying surface, leaving some of the previous colours showing through in places. By now, the blending colours should have assumed a neutral blue/grey look.

■ Add a little Burnt Sienna and French Ultramarine to the mixture to darken it and use this to paint the dark shadow of the arch and its reflection, leaving a tiny gap between the two to suggest a light streak on the waterline. Dilute the colour a little and apply a touch of this across the waterline to suggest the cast shadow of the bridge on the water below the arch.

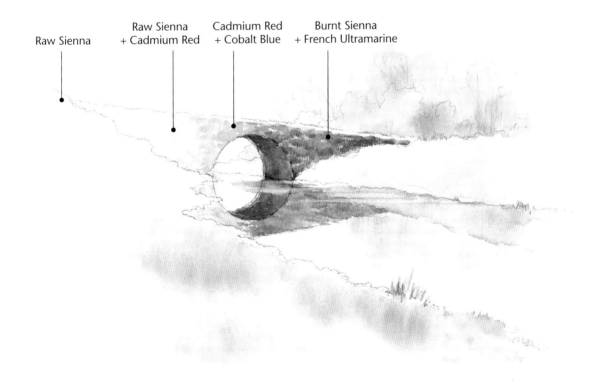

Raw Sienna

Raw Sienna + Cadmium Red

Cadmium Red + Cobalt Blue

Burnt Sienna + French Ultramarine

DEMO The Old Stone Bridge

COLOURS USED

Lemon Yellow
Raw Sienna
Cadmium Yellow
Burnt Sienna
Cadmium Red
French Ultramarine
Cobalt Blue

In a scene like this it is important to establish the position and shape of the river before attempting to draw the bridge. The river appears wider as it approaches you. To achieve this it is tempting to draw the far bank sloping down, but in reality the far bank is usually fairly horizontal.

step 1

First I positioned the horizon line, then the river banks. I dotted in a waterline to mark the position of the bridge and vertical lines to show the centre of each arch and its reflection. I used box-shaped guidelines to establish the shapes. I roughed in some background trees and a large single tree. I damped the paper all over and, while it was still damp, lightly painted the clouds and the main land masses with a pale wash of Raw Sienna. I blended in a touch of Cobalt Blue here and there.

step 2

I damped the sky and river areas and, using a large round brush, painted the cloud shapes with a pale mixture of Cobalt Blue with a touch of Cadmium Red, leaving gaps here and there to suggest form. Before the paper dried I used Cobalt Blue to paint the sky, leaving an unpainted 'halo' around each cloud. I used the same colour and horizontal strokes on the river, pale in the distance becoming stronger nearer the foreground.

step 3

After damping the river ready for soft-edged reflections, I used a flat brush and a pale mix of Lemon Yellow and Raw Sienna to paint the distant trees, leaving the tops rough and random in height. While this dried I blended in a mixture of Lemon Yellow and Cobalt Blue to produce fresh green shading in the nearer trees and painted their reflections into the damp river below each cluster.

step 4

After strengthening the mixture by adding French Ultramarine, I used a small squirrel brush to paint darker foliage. For variation I introduced a little Raw Sienna. I added a touch of Burnt Sienna to darken the mix still further for branches, trunks and hedges. I darkened the reflections at the same time. When the paint was almost dry, I used the palette knife to pull out light trunks in the background trees and mirrored these on the water below.

step 5

I painted the bridge and its reflections, the figure, and the far bank and its reflection, using a light mixture of Raw Sienna and Lemon Yellow. Then I overpainted the far bank with a mixture of Lemon Yellow and Cobalt Blue, using curving brush strokes to suggest the sloping bank.

step 6

I used a mixture of Cobalt Blue and Cadmium Red to overpaint the bridge and reflection and enhance the clothing of the figure, then painted the dark underside of the arch and its reflection with a mixture of Burnt Sienna and French Ultramarine. I used the same colours to add shading to the figure. I overpainted the far bank and its reflection, using a strong mix of Cobalt Blue and Lemon Yellow.

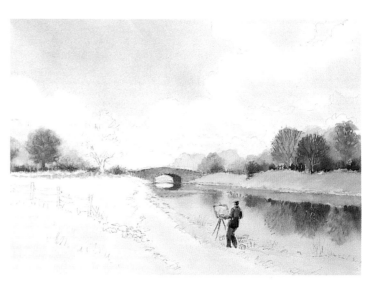

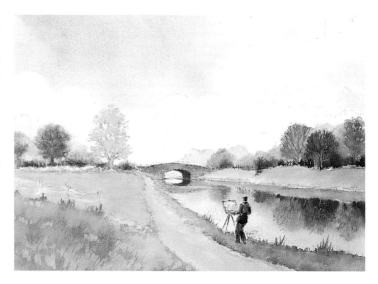

step 7

I painted the grassy banks on the left with a light mixture of Lemon Yellow and Raw Sienna using a large hake and vertical brush strokes. Before the paint dried I overpainted the grassy areas with a mixture of Lemon Yellow and Cobalt Blue.

step 8

I overpainted more colour onto the grassy banks with mixtures of French Ultramarine and Cadmium Yellow. Then I painted the foliage, trunk and branches on the large background tree, starting with a Lemon Yellow and Raw Sienna mix and blending in a little Cobalt Blue.

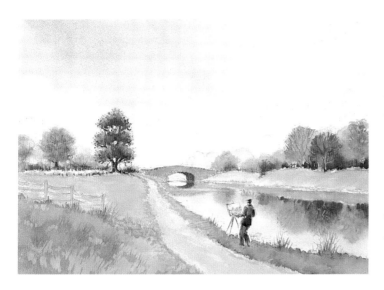

step 9

I applied Raw Sienna to the fence and, before this dried, blended in a little Cadmium Red. I completed the foliage on the large tree, overpainting with Lemon Yellow and Ultramarine Blue. I added more Ultramarine Blue and Burnt Sienna and painted in the trunk, branches and shadows on the foliage. I used the same mixture to indicate the vertical grasses edging the river bank and growing in the foreground.

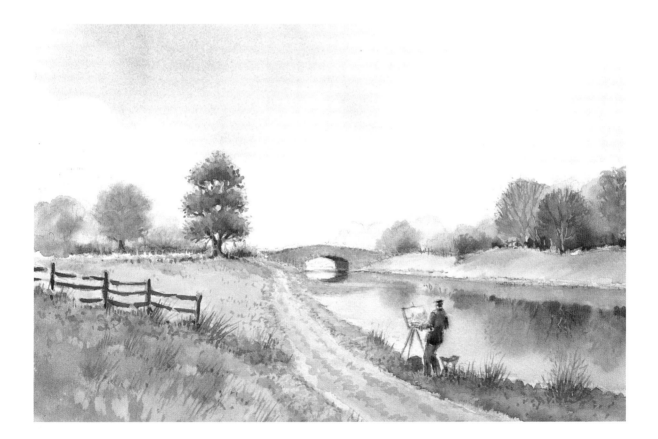

step 10

I painted darker grasses with Cadmium Yellow and French Ultramarine, adding Burnt Sienna for the fence, artist's seat and bag. I used Cadmium Red and Cobalt Blue for the path, adding more blue and Burnt Sienna for the shadows.

▲ *THE OLD STONE BRIDGE*
30 x 41 cm (12 x 16 in)

SEASCAPES

Anyone who visits a coastal region, with its combination of land and sea, is likely to feel overwhelmed by an infinite variety of subject matter. Here is an invitation for any artist to indulge in some atmospheric seascapes as well as exploring the challenge of painting water in its many guises. For beginners, the temptation is to produce the typical holiday postcard scene, but moving around to search for an interesting viewpoint can be much more rewarding.

I live near the coast and it gives me the opportunity to wander along the seashore and find many interesting marine subjects to paint, particularly boats. The average beginner shudders at the very thought of drawing or painting boats, and the duffer's boat often seems to sit on top of, rather than float in, the water. If this problem sounds familiar, some of the ideas in this chapter will help you feel more confident

AND BOATS

Painting sea and sky together

The sea reflects the colours of the sky, so it is logical to paint the sky and the sea one after the other using the same colours. Painting these two large expanses wet-in-wet with a large brush should be done boldly with long, sweeping strokes.

exercise

■ Damp the paper all over with clean water and paint the sky wet-in-wet, using a strong mixture of French Ultramarine with a touch of Cadmium Red added. Use long, sweeping, curved strokes, slightly overlapping in places and leaving small gaps here and there. The colour should become paler in the lower sky near the horizon.

■ Leave a small horizontal gap below the horizon and use the same colours to work down over the sea area, strengthening the colour as you go.

■ When the paper is nearly dry, use a medium round brush to paint ragged ripples, using a pale mixture of the sky colour. The ripples and the gaps between the ripples should become wider as they approach the shore.

◀ *Painting the sea and sky together ensures that the colours match.*

The lighter tones of the horizon help to create the impression of depth.

▶ *THE BIG WAVE*
21 x 30 cm (8 x 12 in)
In a scene such as this, paint the sky and sea wet-in-wet. Leave unpainted paper to suggest wave tops, foam and spray. Using a damp hog brush, pull out a thin line for the horizon and tease out light wave tops – the soft edges will emphasize movement in the water. Use medium sandpaper to gently rub out spray on a large wave.

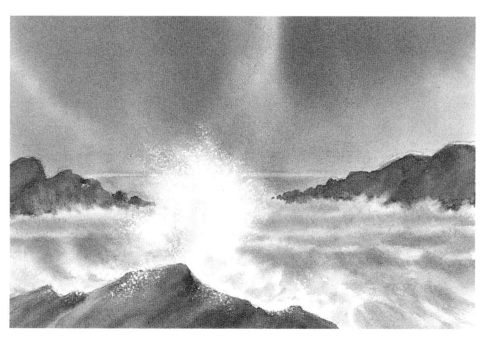

Painting reflections

It is easy to confuse reflections with shadows. A shadow is cast in the opposite direction to that of the light source. A reflection is always placed vertically below it and on still water is a mirror image of it. Ripples may extend the depth of the reflection.

exercise

■ The reflection of an upright mooring post should be vertically aligned to create a mirror image. Use a medium round brush to paint horizontal ripples on the water.

■ To paint a figure leaning over a boat in shallow water use the same technique. If the figure leans to one side the reflection must echo this.

■ A distant boat on the sea needs no reflections, but does need one on a calm lake. Apply a little of the hull colour just below the boat, then apply clean water to the paper just below it. Work this up into the colour from below so the colour blends gently down into the damp area.

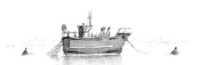

■ A mid-distance reflection on still water will be a mirror image of the shape of the boat itself. Paint it with a small amount of diluted boat colour. The top edge of the boat forms a gentle downward curve, but the reflection is the opposite – a gentle upward curve.

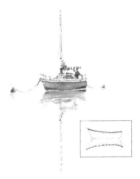

■ A nearer boat reflection will be different because your eye level is likely to be above the boat. The top edge is again a gentle curve downwards and its reflection also a downward curve instead of a mirror image. Paint this with a ragged edge to suggest gentle ripples on the surface – a little darker where the sloping side of the boat meets the water.

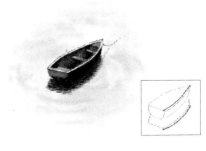

Drawing boats

It helps to use simple shapes as a guide to drawing boats. For both distant boats and those closer to the shore, using box-shaped or rectangular guidelines is a good starting point. For nearer boats at an angle, take account of perspective.

exercise

■ Far distant boats require little detail and a simple rectangle with a slope at each end and a small box on top will suffice, the mast drawn as a thin line.

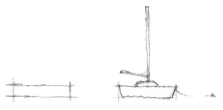

■ For a nearer boat approaching you, draw a rectangle with curved lines at the sides and a vertical centre line – a shallow, inverted 'V' shape for the top edge of the prow, a ragged water line and a small rectangle with sloping sides for the cabin. Extend the mast vertically from the middle of the cabin.

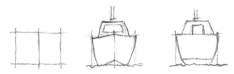

■ A nearer boat approaching at an angle has the vertical bow line off-centre and the side of the cabin is visible. The mast is nearer to the front end of the cabin. The boat moving away at an angle is drawn in the same way, except that the back of the boat and the cabin door will be visible.

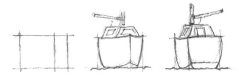

■ For boats close to you, again draw a rectangle. The bottom line slopes up away from you. Draw small marks to divide the top line into three. Draw a shallow upward curve over the two outer segments, a shallow downward curve below the left-hand two and another below the right-hand two. Stop this where it meets the previous curved line. Drop a straight vertical line from the centre of the right segment for the bow and curved lines at both ends and a long shallow ragged curve along the waterline.

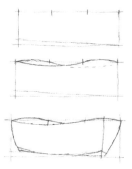

■ For a boat moving away from you use the same technique. Now the back of the boat is visible and drawn as two curved lines.

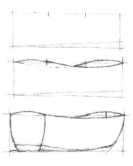

Painting boats

Boat hulls are rounded objects, so a graduated wash will suggest their form much better than a flat wash. Do not paint them too precisely – boats soon lose their pristine appearance after exposure to the elements and a loose approach is likely to look more effective.

exercise

■ Paint far distant boats with a pale blue/violet mixture. When dry, paint the back of the boat and the cabin with a darker mixture. Use a rigger to paint the mast as a thin line.

■ For mid-distance boats use a light wash of French Ultramarine and Alizarin Crimson to paint the side or back of the boat away from the light source. Paint coloured boats in their basic hue and, when dry, overpaint the shadow side with blue/violet. The underside only shows above water at the front and back, so paint these areas as dark horizontal triangles.

■ To paint nearby white boats damp them, then apply a graduated blue/violet wash over the hull to suggest the curved surface. Paint the interior in the same colour, leaving the rim unpainted. Paint coloured boats inside and out, leaving the top edge unpainted. Add shadow areas in darker shades of the same colour.

▼ *Ensure shadows on boats are consistent with the direction of the source of light.*

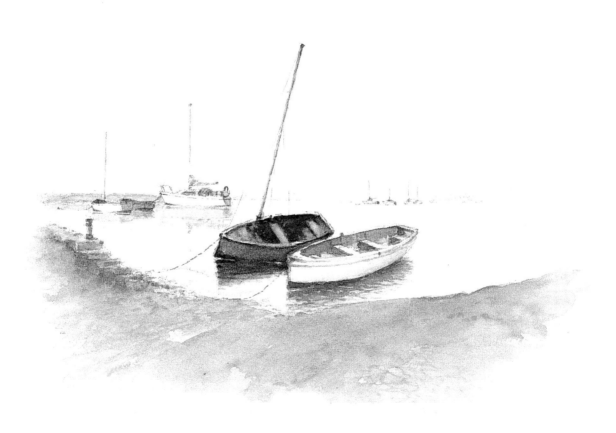

DEMO The Harbour

COLOURS USED

Lemon Yellow
Raw Sienna
Burnt Sienna
Cadmium Red
Alizarin Crimson
French Ultramarine
Cobalt Blue

Seascapes often look more interesting when the tide has receded because pools of water left behind create shapes and patterns that can enhance your painting. Even with the tide out it still makes sense to paint the sky colours down over the damp mud of the harbour as the surface still reflects the sky colours.

step 1

After drawing the horizon line I drew the harbour walls, then carefully placed the boats in random positions to make an interesting formation. Note how the small boat overlaps the large one and the two distant boats are smaller in size. As usual, I damped the paper all over and applied an underwash of Lemon Yellow and Cobalt Blue. This was allowed to dry completely.

step 2

I damped the paper all over with clean water and, when this had soaked in, I applied a graduated wash of Cobalt Blue with a touch of Alizarin Crimson added, working from dark to light on the sky and light to dark from the horizon downwards. I used long sweeping horizontal strokes with a large hake brush.

step 3

I painted the harbour walls and their reflections with a mix of Lemon Yellow and Raw Sienna, blending in Cadmium Red before this dried, and overpainting Cadmium Red mixed with Cobalt Blue. I painted the shadows with French Ultramarine and Burnt Sienna, and the two larger boats and their reflections – one with French Ultramarine, the other with Cadmium Red and Burnt Sienna. The buoys were Lemon Yellow mixed with Cadmium Red.

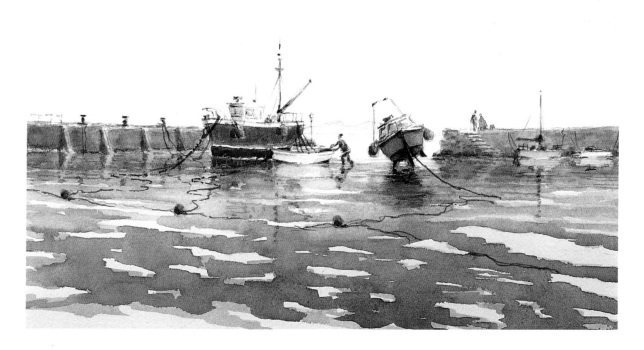

step 4

I overpainted the wall with Cobalt Blue and Lemon Yellow. For the mud I pulled a flat brush from side to side using French Ultramarine and Burnt Sienna. I used the same colours for the bottoms of the boats and much of the detail.

▲ *THE HARBOUR*
30 x 41 cm (12 x 16 in)

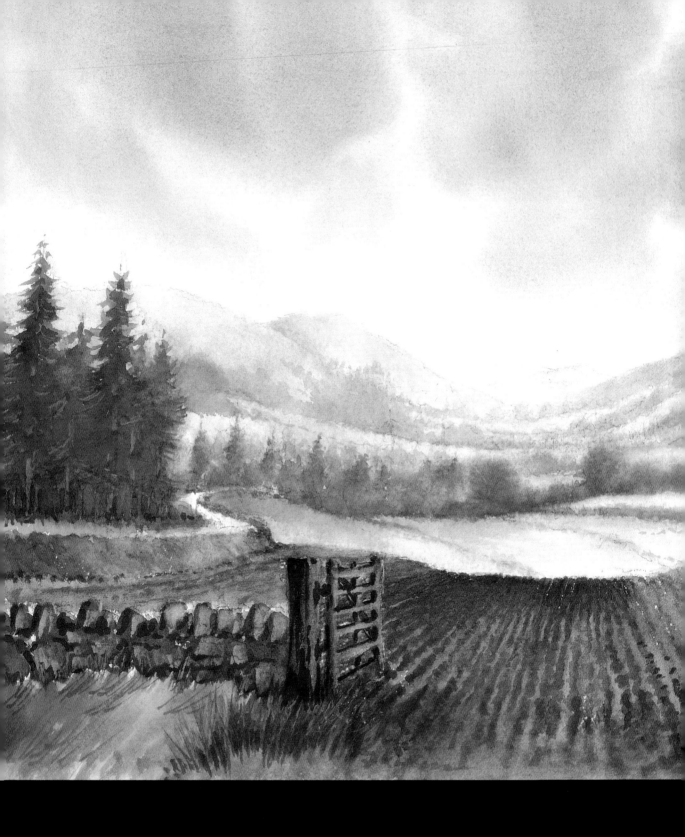

MOUNTAINS AND

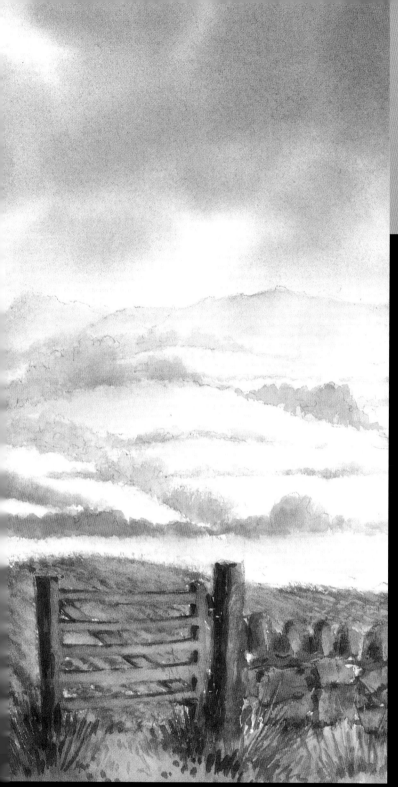

Mountains and headlands make wonderful backdrops for paintings and offer the artist a huge variety of shapes, sizes, textures and colours. Different weather conditions give rise to wide variations in the tonal values of the various land masses, known as aerial perspective, and accentuate the effect of distance. Try to re-create these different tones in your paintings to give them further depth.

Distant mountains are generally pale blue in colour as we view them through the dust particles in the atmosphere. This is why they stand out more clearly after a shower of rain. The closer the mountains are the stronger and warmer the colours appear.

When planning your composition it is important to use irregular shapes and varied sizes to draw the mountains, hills or headlands. Try to be imaginative and remember that no two mountains look exactly alike.

HEADLANDS

Distant mountains

Mountains and headlands can be painted in layers, wet-in-wet in the early stages, then wet-on-dry, to bring out texture and shadows on the slopes. For this exercise imagine that you are looking out across a stretch of water to some rocky headlands and distant peaks.

exercise

■ Draw a horizontal line to represent the horizon and add a distant mountain, ensuring that its baseline is level – a slanting baseline will give the impression that the water runs uphill! Add two larger mountains of varied shape on one side and then draw two smaller ones on the other side. The baselines should be level, but ragged. Make them progressively slightly lower the nearer they are to the viewer.

■ Paint the far distant mountain and the two nearer headlands on the right with crisp edges along the top, using a medium round brush and a pale wash of Cobalt Blue. Allow to dry. Paint the other two large mountains with a pale underwash of Raw Sienna.

■ Add a little Cadmium Red to the yellow mixture and overpaint the two large mountains, matching the brush strokes to the slopes of the mountains.

This means that any lines or gaps in the overpainting will help to emphasize the undulating nature of the terrain. Mix Cadmium Red and Cobalt Blue and, before the paint has dried, blend this over the smaller of the two mountains you have just painted. Paint a layer of Lemon Yellow and Raw Sienna over the headlands on the right, then a second layer on the nearer one to strengthen the colour.

■ Overpaint the larger peaks, first with Cadmium Red mixed with Cobalt Blue, then pull some Burnt Sienna and French Ultramarine into the mixture to darken it. Overpaint the large mountain, blending the colour into the previous layer before it dries, with darker areas to show the shadows. Paint the headlands on the right using Lemon Yellow underwash and varied mixtures of Cobalt Blue, French Ultramarine and Burnt Sienna.

▶ *The different positions of the horizontal baselines of each land mass emphasize the distance between each of them.*

◀ *Build up the colours in stages, ensuring you maintain the tonal variation.*

▶ *Overpaint darker tones wet-in-wet and wet-on-dry to emphasize the shape and texture of the mountains.*

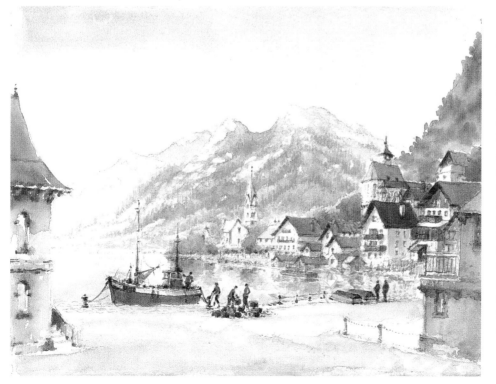

◀ *U N L O A D I N G T H E C A T C H*
*25 x 37 cm
(10 x 14½ in)
The activity in the harbour area is suitably framed by the mass of buildings and the bulk of the distant mountains. The background mountains, although large, are painted in pale, cool colours, so they do not dominate the scene too much, with the nearest one painted in warmer colours. The buildings are painted with little attention to detail.*

Rocks

Arranging rocks is very similar to creating natural-looking clusters of foliage or clouds and is simply a matter of grouping various sizes and shapes to form a balanced composition. Practise using cut-out shapes or large, medium and small sponges as an aid.

exercise

■ Use a soft pencil to draw the rock shapes, overlapping a large rock with a smaller one and adding further small rocks to create a random grouping. Instead of a firm line at the base, use a ragged pencil line to indicate where the rocks nestle in the grass so that they look natural.

■ Using a medium round brush, paint the rocks in a series of wet-in-wet layers, working from light to dark. Start with a pale underwash of Raw Sienna and, before this dries, blend in a touch of Cadmium Red. Add shading using a blue/violet mixture of Cobalt Blue and Cadmium Red, followed by French Ultramarine and Burnt Sienna. Leave a light edge along the top and one side of each rock where the light catches and this will separate the individual rocks.

■ To add texture, darken the paint mixture and apply it sparingly wet-on-dry, using a hog bristle brush. Add final touches with a rigger to suggest fine cracks and crevices.

▶ *Draw rocks in a variety of shapes and sizes to avoid them looking boring.*

▼ *The rocks are painted in layers wet-in-wet. Ensure that the light side of each rock stands out against the dark side of another, as shown in this progressive sequence.*

Dry-stone walls

Stonework can be painted in a similar way to rocks. Keep the bottom of the wall ragged where spiky grass grows over the stones. If a wall is in the foreground, leave an opening to allow the viewer's eye to enter. A gate should be open to avoid creating a visual barrier.

exercise

■ Draw the wall using random shapes for the individual stones. Put some upright, especially along the top, and place others horizontally.

■ Build the colours up as for the rocks on page 80. Start with a pale yellow mix of Lemon Yellow and Raw Sienna, blending in a touch of Cadmium Red or Alizarin Crimson – colour variation is the key to painting this type of subject successfully.

■ Clean the palette and mix Cobalt Blue and Cadmium Red, but avoid overpainting all the stones in exactly the same colour and leave lots of lighter ones for contrast.

■ Add French Ultramarine and Burnt Sienna for darker rocks. For the shadows between the stones mix French Ultramarine and Burnt Umber for a dark blue/grey. Do not paint this as an outline round every stone.

▼ *After drawing the stones in varied shapes and sizes, build the colours gradually in layers.*

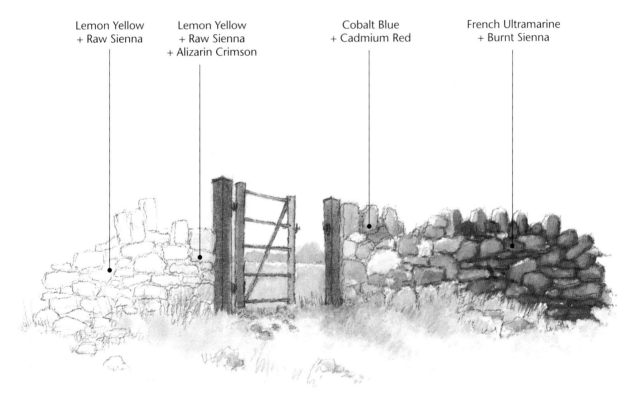

Lemon Yellow + Raw Sienna

Lemon Yellow + Raw Sienna + Alizarin Crimson

Cobalt Blue + Cadmium Red

French Ultramarine + Burnt Sienna

Painting moving water

Moving water is a subject often avoided by beginners, yet it is quite simple to paint and shows up well when set against dark-coloured banks or rocks. It can be painted both wet-in-wet and wet-on-dry, depending on the effect required, with highlighted areas left unpainted.

exercise

■ For a typical waterfall draw rough outlines to show a gorge and the outer edges of the falling water. Where the water drops to a lower level draw a short horizontal line to show a small area of calm water before it starts dropping again. Where the fall is interrupted by rocks draw lines to show the cascading water.

■ Damp the waterfall with clean water. Before this dries completely, use short vertical brush strokes of pale Cobalt Blue to indicate the vertical movement, leaving plenty of unpainted paper here and there for highlights. Add a few small curving strokes to show the turmoil where the water strikes the river below. Blend in a little darker colour wet-in-wet before this first layer dries completely.

■ The rocky surroundings can be painted in a variety of colours, but the tones next to the flowing water need to be dark to contrast with the light water. Start with a mix of Raw Sienna and Lemon Yellow and blend in Cadmium Red and Cobalt Blue. Add Burnt Sienna and French Ultramarine to paint the rocky outcrops. Use a dry mixture and a hog bristle brush and apply vertical streaks of blue/grey to emphasize the flow of the water. Leave unpainted paper for sparkling highlights and contrast.

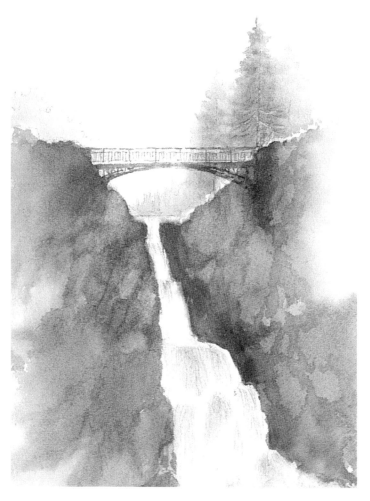

◄ *The dark rocks at the sides of the ravine contrast well with the falling water. Movement of the water is shown by using a dark blue/grey mixture, dry brushwork and vertical brush strokes.*

■ Rivers and streams, where there are abrupt changes of level, are painted in much the same way as waterfalls. Draw a river bounded by rocks in the foreground and trees at the edges. Paint the trees in pale blue/green (mixed from Lemon Yellow, Cobalt Blue and French Ultramarine), then paint the flat area of water blue/green using horizontal brush strokes. This stretch of river just before the fall can appear dark, flat and calm.

■ Paint the water between and below the rocks wet-in-wet with Cobalt Blue, taking the brush strokes in the direction of the flow. Leave lots of white unpainted paper. Before the paint dries completely, blend in darker shades of blue/grey, using French Ultramarine and Burnt Sienna. When dry, use the same colours to make a stronger mixture to paint the protruding rocks after a preliminary underwash of Raw Sienna.

◀ *Above the falling water the river appears fairly still and dark, but where it drops down it creates light edges – shown by leaving the paper unpainted. The flowing water is painted with various shades of blue/grey wet-in-wet. The rocks are varied in size and shape and dark in colour to contrast with the water.*

▶ *THE RIVER AT BETWS-Y-COED*

37 x 56 cm
(14½ x 22 in)
The water is painted wet-in-wet at first, then dry brush technique is used to emphasize the faster flow where it cascades over the rocks in the foreground. Unpainted areas of paper accentuate the white frothy highlights on the water. The light area of trees in the background adds to the feeling of depth.

DEMO Canadian Lake

COLOURS USED

Lemon Yellow
Raw Sienna
Cadmium Yellow
Burnt Sienna
Cadmium Red
Burnt Umber
French Ultramarine
Cobalt Blue

A North American scene was the inspiration for this painting, but I decided to change the high viewing position to a lower level. Generally, scenes like this appear more spectacular seen from near ground level because the mountains really tower over you. We shall now find out if the idea works.

step 1

I started by drawing a line to position the far edge of the lake, then outlined the main land masses, the mountains and larger trees. For more interest I added some large foreground rocks. I damped the paper all over with clean water and applied my customary underwash of Lemon Yellow and Raw Sienna over the main areas, leaving some parts unpainted. This was allowed to dry completely.

step 2

I damped the sky area down to the tops of the mountains, the lake, the falls and the water below and, using a mix of Cobalt Blue and French Ultramarine, painted the sky down to the mountain tops, leaving a light area showing through the valley. I painted the same colour across the lake and water below the falls using horizontal brush strokes.

step 3

Using a paler version of the sky colour I used a medium round brush to paint the distant mountain peak, leaving unpainted paper to suggest the snow-covered slopes. I used the same technique and darker mixtures to paint the other mountain tops, adding Cadmium Red to warm the colour in places. I added a tiny amount of Burnt Sienna for the darker areas, keeping the mountain on the left in shadow.

step 4

I moved on to the nearer peaks, starting with a wash of Lemon Yellow and Raw Sienna into which I blended a little Cadmium Red while still damp. I overpainted in places with a mixture of Cadmium Red and Cobalt Blue, and of Lemon Yellow and Cobalt Blue over the tree-clad lower slopes.

step 5

I used a large hake and a mixture of Lemon Yellow and Raw Sienna on the foreground areas, blending in Cadmium Red and then Cobalt Blue in places. I added French Ultramarine to darken the river banks.

step 6

Using a small squirrel brush, I started painting the large trees with Lemon Yellow and Cobalt Blue and added French Ultramarine and Burnt Sienna for the darker shading. I used a mixture of Cobalt Blue and Cadmium Red for the foreground rocks, then added Burnt Sienna for the shadow areas.

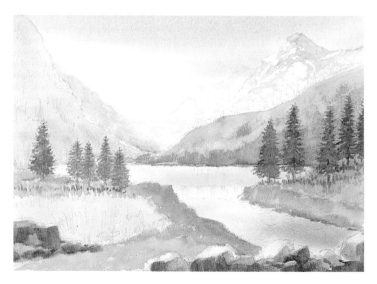

step 7

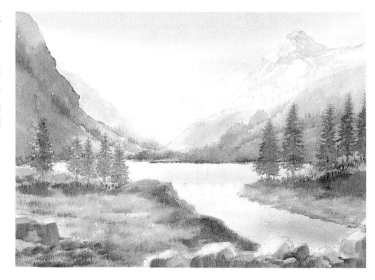

I damped the paper and used a hog brush to gently lift out colour on the right-hand slopes to improve the tonal contrast. I blended in a mixture of Lemon Yellow and Raw Sienna. When this was dry I added Cobalt Blue and painted the tree lines on the slopes. I overpainted the mountain on the left with a mix of Cadmium Red and Cobalt Blue, then blended in a mixture of French Ultramarine and Burnt Sienna wet-in-wet for shadow areas and to show lines of trees.

step 8

I finished the foreground grasses, overpainting a mixture of French Ultramarine and Cadmium Yellow with a medium round brush, and adding Burnt Sienna for the darker stems and shadow areas under the trees.

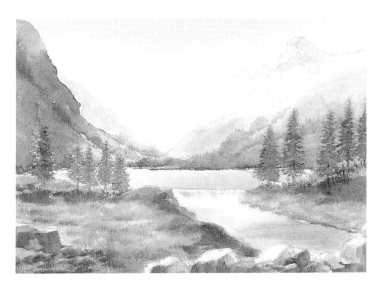

step 9

I touched in a little green colour, mixed from Lemon Yellow and Cobalt Blue, for the tree reflections at the back of the lake. I damped the lake and water below the falls and used a mixture of Cobalt Blue and French Ultramarine to darken each area, using horizontal strokes and leaving a crisp edge at the top of the falls. When the paper was dry I used a dry mix of blue colour and a hog brush to paint vertical streaks for the falling water.

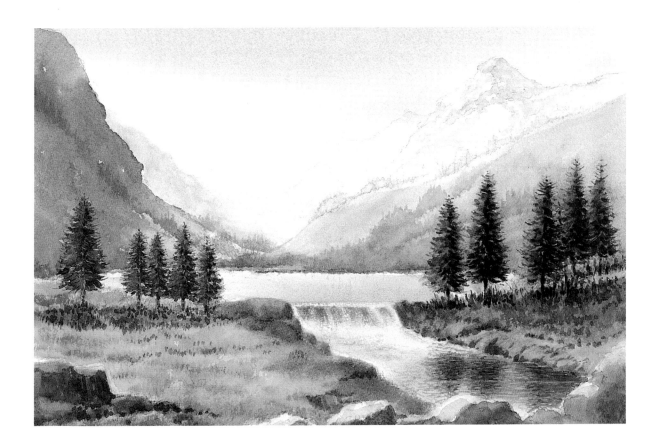

step 10

I overpainted the larger trees with French Ultramarine and Lemon Yellow, then added Burnt Umber for darker shading, using the same colours for the reflections. After darkening the falls I used sandpaper to lift out highlights.

▲ *CANADIAN LAKE*
30 x 41 cm (12 x 16 in)

BUILDINGS IN THE

Painting buildings can cause problems for both experienced and new artists. Some people's brains go blank at the mere mention of the word 'perspective', but by following a few basic rules it can be a simple process. Avoid being too precise or attempting to reproduce buildings in great detail – leave that to architects and photographers. Personally, I enjoy painting old buildings, the more ramshackle the better, because they have more character.

An important factor, often overlooked, is to make a building the right size for the painting. To me, there is nothing worse than seeing a painting where the building does not quite fit on the paper or where a very small building is positioned right at the edge of the painting as if it is about to fall off the landscape. It pays to plan your composition before you start painting – give your building room to 'breathe'

LANDSCAPE

Simple perspective

To draw buildings think of them as boxes. Hold the box at different angles and move your viewing position up and down – then it becomes clear in which direction the lines of the roof, gutter and ground level run. Think of adjoining buildings as two separate boxes.

exercise

■ Draw a horizontal line for the ground level and position the two vertical end walls first. Draw the roof and gutter line more or less horizontal (with a distant building perspective has little effect). Draw the two ends of the roof overlapping the walls. The chimney and windows can be drawn as simple rectangles. Use ragged lines throughout to keep things loose.

▲ *Distant building on level ground.*

■ When the same distant building is seen at an angle, the end wall is visible. Walls are still vertical and the roof, gutter and ground level are all roughly horizontal. To find the apex of the roof draw two diagonal lines from the corners of the box shape formed by the end wall and from where the two lines meet extend a vertical line upwards to meet the roof line. Draw the sloping roof lines from this point. For simplicity the far end of the roof can be drawn roughly parallel to the nearer one. The side of the chimney can now be seen and drawn as a

simple rectangle with straight sides. Note the chimney sits astride the roof, not on top of the ridge.

▲ *Distant building at an angle.*

■ If you move closer to a building at an angle your starting point is the corner of the wall closest to you, so draw this first, then two vertical lines for the other walls. The roof, gutter and ground lines slope away from you towards the horizon line (eye level), so draw a rough guideline to show this, then draw the lines all pointing towards an imaginary vanishing point on the horizon line (the closer you are

▲ *Building in the foreground.*

to the building the closer the vanishing points and the steeper the angles of the roof line and ground line). The gutter and ground lines of the end wall run towards a vanishing point on that side of the building. Establish the apex of the roof and complete the drawing as before.

■ A building on a hill is drawn in a similar way to the previous one except that, as you are looking up at it, the lines of the roof, gutter and ground level (which is hidden from view in this instance) all slope *down* away from you towards the horizon line. Draw dotted guidelines to show the ground level although they are not visible from below.

■ When you view a building from above, the horizon line (eye level) is well above the building. So the roof, gutter and ground level lines all slope *upwards* towards the horizon line. Once again, make the nearest vertical wall your starting point before drawing any guidelines.

▲ *Building on a hill.*

▲ *Building in a valley.*

► *MAGGIE'S HOUSE*

37 x 56 cm (14½ x 22 in)
Viewed from an angle a short distance away, the roof ridge and guttering slope down away from us towards the horizon line (eye level), while the ground line slopes up towards the horizon line. When you are standing this close to a building the sides of the walls appear to slope in at the top, but it is generally better to paint them vertical.

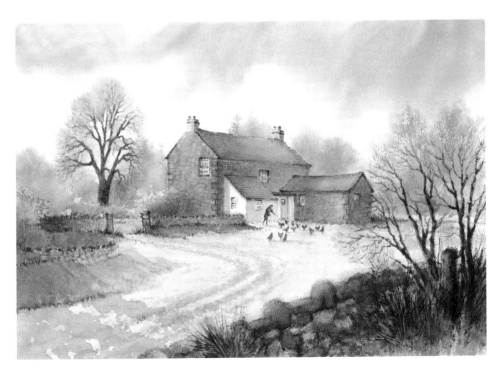

Painting buildings

Buildings should be painted with a loose look rather than very precisely. I like to blend in colour wet-in-wet in layers, then add detail rather than painting a wall at a time. Avoid painting outlines all round the edge, which looks simplistic.

exercise

■ To paint a white building lay a light wash of Raw Sienna on the roof and shadow side of the building. Using a medium round brush, paint Cobalt Blue over the windows with a single brush stroke. Add Burnt Sienna to darken the mix and paint a small blob into the lower part of the windows. Paint the wall and side of the chimney in shadow with a pale mix of French Ultramarine and Alizarin Crimson.

■ Add more blue and Burnt Sienna. Overpaint the roof and thin edge of the far roof line. Add a touch to the window reveals and door. Add more blue and Burnt Sienna to darken the mixture further and add a few touches to the ridge line and gutter at the ends, the chimney, window sills and doors. Touch a little diluted reflected sky colour onto the extension roof.

▲ *Stonework can be painted by blending various colours wet-in-wet to make neutral tints. These need not look bland.*

■ To paint a stone building apply the colour gradually. Start with an underwash of very pale Raw Sienna. Add a touch of Cadmium Red and blend this into the walls wet-in-wet just before the first layer dries out.

■ Mix Cobalt Blue and Cadmium Red and overpaint the walls and shadows on the roof. Add a little Burnt Sienna and some French Ultramarine to make a darker blue/grey colour and paint the roof, window reveals and walls in shadow. Add more French Ultramarine and Burnt Sienna to darken the mixture to emphasize the ridge, guttering, roof returns and window sills. Mix French Ultramarine and Alizarin Crimson for a pale violet to paint the roof, tower and walls in shadow.

▼ *A pale yellow underwash adds interest to the shadow side of a white building.*

Framing buildings

Trees can often be painted around buildings to make them stand out better. But, too often, the trees smother the building or detract from it, so they need to be positioned sensibly and the colours need to be selected carefully to contrast with the building.

exercise

▶ *The duffer often paints trees as a very uniform cluster. Instead, make a break in the trees, so that they overlap the building part way up the walls or roof.*

▶ *Another typical duffer's 'mistake' – a tree line that finishes right on the corner of a building or roof line. Move it away from this point. Avoid two near-identical clusters.*

▶ *This example shows how to frame a building with trees to bring out the shape.*

■ Paint a line of trees adjoining a building, making sure your painted line leaves a neat edge to the building. Try to leave part of the roof clear of the trees, varying the height on each side of the building so that the trees do not appear to be joined to the point of the roof or other obvious place.

■ Paint a band of fir trees of varied shape, size and colours behind a building in the snow. Allow an unpainted space on the roof to suggest the snow covering and paint the tree line neatly up to this. Framing a building like this works well in snow scenes because the dark trees create a clean edge to the snow-covered roof as well as the building itself.

▼ *The dark trees frame the building, but the varied shapes and sizes set off the clean line of snow. To suggest smoke rising from the chimney, the paper is damped and colour lifted out with a hog brush. The snow in shadow is painted in Cobalt Blue.*

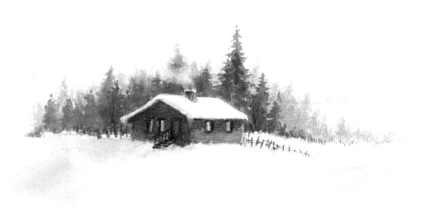

DEMO The Barn

COLOURS USED
Lemon Yellow
Raw Sienna
Burnt Sienna
Cadmium Red
French Ultramarine
Cobalt Blue

Barns make excellent subjects because, despite their simple construction, they have a lot of character. The weathered wood can be painted in a variety of colours wet-in-wet and wet-on-dry and dry brushwork can be used to bring out the textured surfaces. Including farm animals in the scene helps to give a sense of scale.

step 1

I drew the barn fairly large as it was to be the centre of interest and chose a low viewpoint. I framed the scene with tall foreground trees on one side and a smaller thin bush on the other. I damped the paper all over with clean water and applied a pale wash of Lemon Yellow and Raw Sienna to the main areas, then allowed it to dry completely.

step 2

I damped the paper down to the horizon line. Then I used a hake to sweep a mix of Cobalt Blue, French Ultramarine and Cadmium Red across the sky, using curved strokes and leaving gaps between the clouds. I used pale sky colour for the distant hill and added more Cobalt Blue and Cadmium Red to paint the large hill. I painted the barn, fields and grassy areas with Lemon Yellow and Raw Sienna, blending in Cobalt Blue in some places and Cadmium Red in others.

step 3

I continued to paint the distant tree line and strengthened the barn, fields, fence and grassy areas, adding Burnt Sienna to the mix where necessary. I applied pale Cobalt Blue to the large foreground trees, leaving one edge unpainted. Then I overpainted a mixture of Cadmium Red and Cobalt Blue to form areas in shadow on the barn, distant buildings, track, fence, large foreground trees and rocks.

▲ *THE BARN*
30 x 41 cm (12 x 16 in)

step 4

I used a dark blue/grey mixture to paint heavy shadows. With a rigger I painted lines on the bark of the larger foreground trees, pulled out thin branches and darkened the branches on the smaller trees.

Index